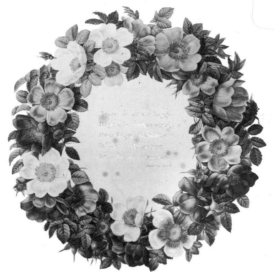

BOTANICAL ILLUSTRATION

BOTANICAL ILLUSTRATION

RONALD KING

Ash & Grant

*No work on botanical illustration can be undertaken without drawing
heavily upon the exhaustive exposition of the subject written by
Wilfrid Blunt and published nearly 30 years ago under the title*
The Art of Botanical Illustration.
*His careful examination of the enormous range of works he was able to locate
and considered assessments of the achievement of each artist are the
inspiration for this book which, undertaken in accordance with his own wish
that the wealth and beauty of the material he examined should be made
more widely known, I dedicate to him.*

Ronald King

First published in 1978 in the United Kingdom by
Ash & Grant Ltd, 120B Pentonville Road, London N1 9JB

Page 1 : Wreath of roses by P. J.
 Redouté, from his book,
 Les Roses (1817–24).
 3 : Heads of rushes (*Scirpus
 lacustris L.*) drawn by
 Leonardo da Vinci,
 c. 1508–9.

Botanical Illustration text © Ronald King 1978
Layout and cover design © Ash & Grant 1978

Designed by Malcolm Smythe

British Library Cataloguing in Publication Data
Botanical illustration
 1. Botanical illustration
 I. King, Ronald, b. 1914
 743.9'3409 QK98.2

Casebound ISBN 0 904069 30 3 Paperback ISBN 0 904069 31 1

Set in 11/12 pt Imprint 101 and printed and bound in Great Britain by
W. S. Cowell Ltd, Ipswich

BOTANICAL ILLUSTRATION

Long before men settled down to pursue the arts of agriculture ten thousand years ago, they had doubtless discovered some of the plants that could be used to assuage the pain of illness or injury, as well as those that were good to eat. The urge that prompted them to draw animals, sometimes with high artistic skill, upon the walls of caves did not, however, induce them to record plants in the same way, even though they used them. It was not until civilization arose in Sumeria, along the banks of the Tigris and Euphrates, in the land that is now Iraq, that plants began to appear in art, and then it was merely as a motif in decoration. This use cannot be regarded as botanical: the first representations that can be put in this category are the bas-reliefs on limestone of plants which in about 1500 BC, Pharaoh Thotmes III of Egypt caused to be carved on the walls of a small hall at the end of the Great Temple of Karnak, in which he recorded plants brought back as part of the spoils of his campaigns in Syria. Some of these are easily recognizable.

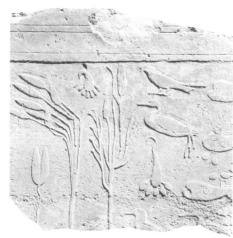

Part of the limestone bas-reliefs on the walls of the small hall at the eastern end of the Great Temple at Karnak in Egypt, portraying plants brought by Thotmes III from Syria. This is the earliest known collection of botanical illustrations and depicts about 275 plants. This section illustrates water plants.

The Egyptians were not exceptional in leaving evidence of an interest in plants. Surviving specimens of the art of the inhabitants of Crete and Assyria show that they also admired the beauty of plants, but their use of them does not seem to have contained any botanical element. A similar interest appears in Greek art, but the Greeks went further. In about 400 BC they founded the science of botany, which arose out of the study of the healing properties of plants. It was the work of the Greeks in cataloguing plants of medicinal value that led in Hellenistic times to attempts to provide pictures that could be correlated with descriptions. The Roman writer Pliny the Elder, in his *Natural History*, gives the names of some of those who made such pictures; they are the first botanical illustrators known by name to us. 'Cratevas [usually now spelled Krateuas]', says Pliny, in a translation of 1601, 'likewise, Dionysius also and Metrodorus . . . painted every hearbe in their colours, and under the pourtraicts they couched and subscribed their severall natures and effects.'

Pliny was writing of the first century BC and the Krateuas whom he mentions, who was physician to Mithridates VI Eupator, became, to some extent by chance, an important figure in botany. Krateuas' own paintings perished, but an illustrated version of *De Materia Medica* of Pedacius Dioscorides, a physician of the first century AD, which was prepared in AD 512 for the Princess Juliana Anicia in Constantinople, contained what are almost certainly copies of some of Krateuas' paintings. This manuscript, one of the sparks that kindled the Renaissance, was brought to Vienna in 1569 where it is still preserved. It is known as the *Codex Vindobonensis* and contains about 400 pictures of plants, many boldly and naturalistically executed. They are superior to anything that followed them for the next thousand years.

Dioscorides' work was one of the basic collections that comprised the corpus of information about plants that was passed down to posterity through the thousand years that followed the downfall of the Roman Empire in the West. It does, indeed, shine like a light through the days of the Dark Ages but, like a light, it becomes progressively dimmed with dis-

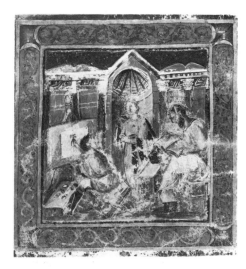

Illustration from the *Codex Vindobonensis* showing an artist, possibly Krateuas, painting a mandrake plant while Dioscorides himself consults a book.

An illustration from the *Ortus Sanitatus* (1485) showing the crudeness of the figures in the first printed herbals.

A drawing by Hans Weiditz from Brunfels' *Herbarium Vivae Eicones* (1530) which introduced a new realism into the drawing of plants.

Lifelike irises, lilies and aquilegias painted by Hugo van der Goes in the fifteenth century.

tance. The pictures of plants in this and other works were copied in herbals from century to century in the monasteries and gradually became more and more corrupt, simplified and stylised until by the end of the fifteenth century they are so poor they can have been of little use.

Although the herbals of the northern countries do not seem to have benefited from it, Flemish and French miniaturists began at the end of the fourteenth century to paint plants with more attention to nature. Stylised manuscript borders gave way to those with more realistic representations. The most remarkable, perhaps, is the *Book of Hours* made by Jean Bourdichon between 1500 and 1508 for Anne of Brittany, which is in the Bibliothèque Nationale, Paris. In this work more than 340 plants of the local flora of Touraine are displayed. *The Grimani Breviary*, made about 1510, in St Mark's Library, Venice, shows 59 different flowers on its pages. The lack of progress in northern herbals was not paralleled in the south. A manuscript of Benedetto Rinio, also in St Mark's Library, contains nearly 500 full-page paintings of plants by Andrea Amadio which are very realistically painted and notable, for the first time in 900 years, as the beginning of positive improvements in botanical illustration.

Other painters soon followed the miniaturists. Works which included plants by the brothers van Eyck, Hans Memling, Gerard David, van der Goes and others during the fifteenth century, and the botanical studies of the great Albrecht Dürer around the end of the century, are obviously painted from life. The change spread to Italy and before long naturalistic flowers appeared in landscapes and as ornaments in other paintings. Thirty out of 40 plants in Botticelli's *Primavera* are identifiable botanically and Leonardo da Vinci himself made flower studies from life, some of which have survived.

In spite of this movement among painters, the first printed herbals which were issued from 1481 onwards continued to copy the degenerate figures for their illustrations, using woodcuts. Even where new figures were attempted, the drawings were often crude, although there were exceptions which showed a nearer approach to nature. It was not until 1530 that attention was turned fully upon the plant and an effort made to draw it as it actually appeared. In that year Otto Brunfels issued from Strasbourg his *Herbarium Vivae Eicones*, with illustrations by Hans Weiditz, which were designed to be coloured, shading being kept to a minimum. Here was something new. With superb craftsmanship Weiditz had looked at the plants handed to him by Brunfels and recorded faithfully what he saw, even to torn or wilted leaves and withered flowers. As a true artist he could not help at the same time putting his artistic soul into his drawing, bringing out from the plant all the beauty that was in it, so that the immediate reaction on looking at one of his pictures is that of pleasure. By great good fortune, his work was interpreted on the wood by engravers of equal skill, with results that make his work a high point of artistry and woodcutting in the portrayal of plants.

Twelve years later the Isingrin Press at Basle published the *De Historia Stirpium* of Leonhart Fuchs, a finely-produced work on high quality white paper, well designed and clearly printed, and containing more than double the number of pictures in Brunfels, again sparsely shaded to facilitate colouring. These were also excellent, even though the charge has been levelled against them that the artists tended to idealize the plants rather than paint them exactly as they were in the Weiditz manner. Their popularity was such, however, that they were used and copied in many other herbals over a long period of years, up to 1774.

Another work illustrated with woodcuts which enjoyed tremendous success was the Latin version of the *Commentary on Dioscorides* published by Pierandrea Mattioli in Italy in 1554. It was illustrated in early editions with 562 small woodcuts which differed from those of Brunfels and Fuchs in being much more liberally shaded. This work was the first really practical tool provided for the physician to enable him to identify Dioscorides' plants and went through 40 editions. The illustrations could, however, have been improved, and some later editions were provided with a larger

set of woodcuts made by Giorgio Liberale of Udine and Wolfgang Meyerpeck which showed greater competence than the originals.

Woodcuts used in other herbals never reached the heights of those in the works of Brunfels and Fuchs, and it is not until the era of the Plantin publishing house in Flanders in the second half of the sixteenth century that further work worthy of note was produced. Plantin issued the numerous publications of the botanists Rembert Dodoens, Charles de l'Ecluse and Matthias de l'Obel, illustrating them with woodcuts based on the paintings of Pierre van der Borcht, most of which were made between 1565 and 1573. About 600 of the 1,856 paintings of plants in the collection seem to have been used in the productions of the Plantin press. Where the artist had the live plant from which to draw, he finished his paintings in full colour, but drawings from dried specimens were left uncoloured.

Another set of woodcuts emanated from the famous botanist Conrad Gesner, a Swiss who died of plague in 1565 leaving his *Historia Plantarum* unfinished, with 1,500 drawings already assembled. These were acquired and in part used by the German botanist Joachim Camerarius. Others were published by Christoph Jacob Trew in the eighteenth century. The *Hortus Medicus* of Camerarius was illustrated with plates by various artists which were accurate, well furnished with botanical detail and excellently engraved. The last book of note illustrated by woodcuts was Olof Rudbeck's *Campi Elysii* which was conceived on a large scale. Eleven thousand drawings were made for it, but they were destroyed by fire in 1702. Only two copies of the first volume are extant, and not many more of the second.

The traditions of the Flemish miniaturists of the early sixteenth century descended to Georg Hoefnagel, son of an Antwerp diamond merchant, who was born in 1542. Hoefnagel, who travelled widely, caught the attention of princes, and created some marvellous works for his patrons. In these manuscripts, while following his predecessors, he did not confine his flowers within rigid borders but spread them at his will on the margins and achieved a naturalism of a high order. These works, the chief of which were a *Missale Romanum* made for Archduke Ferdinand of Tirol in 1582–90, the *Four Kingdoms of Living Creatures* and the *Schriftmusterbuch* of Georg Bocskay, illuminated in 1591–94, were finely painted and showed immense industry. They are of great interest because the plants illustrated contain many from the newly-discovered lands of Mexico and Peru which are shown for the first time in Europe. Italian artists of this time were also producing work of a high standard. The Veronese, Giacomo Ligozzi, who worked for the Medici princes, made many paintings of plants in oils and tempera, some of which show an attention to detail that could only have come through from the most acute observation. Domenico dalle Greche painted most of the thousand or so paintings in the five volumes of the Venetian herbal *I Cinque Libri di Piante* which was made for Pietro Michiel and is in the library of St Mark's, Venice.

The influx of new plants stimulated flower-painting generally and in some cases the painter had himself been overseas to the newly-discovered lands. Jacques Le Moyne de Morgues, an artist and cartographer, took part in an expedition to America in 1564. A Huguenot, he eventually took refuge in England, publishing his *Clef des Champs* in 1586. This contained about a hundred small square woodcuts, mostly of plants. Some of the originals of these which have survived are very pleasing and reveal a sensitive delicate touch which hardly comes through in the woodcuts made from them for the book. Drawings actually made overseas at about the same time as Le Moyne published his book were the work of John White, who was with Raleigh's unfortunate first colony in Virginia in 1585 and 1586. They derive more of their value from their historic connection than from their quality.

The era of the woodcut passed with the beginning of the seventeenth century and etching and line-engraving came into fashion. The two processes have often been used together on the same plate, but are quite distinct. In etching the design is eaten into the copper plate by acid while in line-engraving a tool called a burin is used to cut the lines on the metal.

A large woodcut of a water-lily from one of the later editions (1585) of the Latin version of Mattioli's *Commentary on Dioscorides*, first issued with small woodcuts in 1554.

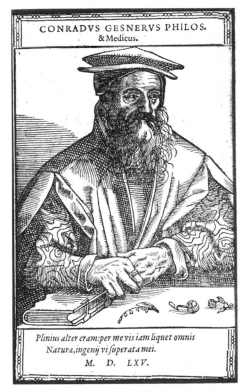

Conrad Gesner began his career teaching Greek and published a Greek-Latin dictionary in 1537, but in 1541 he took a degree in medicine and joined that band of naturalists of extraordinary vigour and industry who flourished in the sixteenth century and who, by their compilations, laid the foundation for later work. He rapidly acquired a reputation for immense biological knowledge and was consulted by others as the ultimate authority.

A plate from a 1744 edition of the *Phytobasanos* of Fabio Colonna.

An attractive plate from Pierre Vallet's *Le Jardin du très Chrestien Henry IV* (1608).

A plate engraved by Matthäus Merian for his *Florilegium Renovatum* (1641).

Both processes were well-established as methods before they were applied to botanical drawing. Works incorporating etched pictures of flowers began to be published in the 1590s, the first botanical book with etched drawings being the *Phytobasanos* of Fabio Colonna published in Naples in 1592. Another work by Colonna, *Ekphrasis*, published in parts in 1606 and 1616, contained similar etched illustrations. The drawings in these works are small, being set within heavy borders, but they have an informal charm and are botanically accurate. The original drawings from which the etchings were made have survived and show Colonna as an artist of ability.

In 1608 there was published in France a work which has peculiarities by modern standards. The author, Pierre Vallet, described himself as embroiderer to the King, but was employed in the royal gardens and the book is entitled *Le Jardin du très Chrestien Henry IV*. The connection between embroidery and gardening arose at this particular time because of the vogue in the garden for 'parterres de broderie' which were highly intricate interweaving patterns of beds, often box-edged, making use of coloured earths as filling instead of flowers, similar patterns being used for furnishings and other material. The book is, in fact, what is called a 'florilegium', that is, a book with portraits of flowers included for their ornamental value. It is a work of great beauty and appears to have been both drawn and engraved by Vallet. It contains 75 plates, including some of plants from Spain and the islands off the coast of Guinea. Some of the plates are engraved, but the most effective are etched, small dots being used to provide gradations in tone. Another florilegium, that of Johann Theodor de Bry, entitled *Florilegium Novum* (1611), has engraved plates of high quality but a number of them are copies of Vallet's etched plates. In general, the original etching is to be preferred to the engraving. De Bry's florilegium was itself raided to provide illustrations for another ornate florilegium, that of Emanuel Sweert, published in 1612, which is a kind of sale catalogue, since it advertises the shop where the plants may be obtained. The plates are mostly poor imitations of the originals of Vallet.

Paul Reneaulme's *Specimen Historia Plantarum* of 1611 is of a different calibre. It contains only 25 plates, but they are etchings of superb quality, both as regards the artistic treatment of the plant and the technical aspects of the reproduction. Another much larger set of engravings was produced by Pierre Richer de Belleval, the founder of Montpellier botanic garden. Belleval drew the flora of Provence and Dauphiné from living plants during his botanical wanderings and had some 500 of them permanently recorded, the small plates being accurate enough, but rather stiff in drawing. Only a few were ever published, and that was not until many years later. Basil Besler's *Hortus Eystettensis* was the reverse, the plates, 'curiously cut in brasse', being exceptionally large. Besler, whose patron was the Prince Bishop of Eichstätt, worked for 16 years on the drawings of plants in the bishop's garden. The work contains 374 plates portraying upwards of a thousand flowers of 667 species. The plates are decorative and well-designed and, because of their large size, extremely impressive. Crispin de Passe the Younger, born into a family of engravers at Cologne about 1590, published the *Hortus Floridus* in 1614. It contained about 200 engravings which had a novel atmosphere, because the artist drew many of them from so low an angle that, though they are shown growing in the soil, they are outlined against the sky. They were greatly admired and freely borrowed for other works, even as late as 1757. Langlois' attractive *Livre des Fleurs*, published in 1620, also had an individual style, some plates being engraved and others etched. Although the plates of the *Canadensium Plantarum Historia* published by Jacques Philippe Cornut in 1635 do not compare with some more impressive works, they are adequate and pleasant enough.

The social disruption caused by the Thirty Years War in northern Europe and the Cromwellian era in England reduced botanical effort for a time in those countries. In France Gaston d'Orleans employed Nicolas Robert to paint flowers at Blois. The paintings he produced and those of the earlier Daniel Rabel were the beginning of the large collection now housed in the Musée d'Histoire Naturelle. In 1622 Daniel Rabel pub-

lished a *Theatrum Florae*, some of the drawings for which are in the Bibliothèque Nationale. The engravings in the book are little better than those of Vallet or de Bry: the paintings from which they were drawn are on another plane, being superb in the delicacy and freshness of colour achieved by the transparent wash technique, with little use of opaque tones, which has been used. Nicolas Robert was asked by the Baron de Sainte-Maure to make an album of flowers for his fiancée Julie d'Angennes. In 1641 he produced the work known as the *Guirlande de Julie*, in which he collaborated with Jarry as leading calligrapher of the day and several poets, including Corneille, who contributed madrigals. There is a beautiful garland on the title page and the flowers chosen are the most showy of garden flowers, executed with high skill and great charm. It was this work that led him into the employ of Orleans.

By the time Gaston d'Orleans died in 1660, Robert had filled five large folios with paintings, mainly of flowers, made at Blois. In these he reduced outline to a minimum and used fine hatching to create form and texture with great effect. After 1664 Robert worked for the King at Paris and Versailles, making replicas of his drawings for Colbert. When the Academie Royale des Sciences decided to publish a history of plants, he was the obvious choice for illustrator. By 1692 some 319 plates had been engraved, mostly from paintings by Robert, who had died in 1685 but, although these were published without text in 1701, the full work engraved partly by himself and partly by Abraham Bosse and Louis de Chatillon, both masters of their craft, did not appear until 1788. Spaëndonck, himself the equal of the best, described the illustrations as the finest that had even been produced. Robert was followed by a less gifted successor, Jean Joubert of Poitiers, but Claud Aubriet, who followed Joubert, restored the standard. Aubriet worked for the great French botanist Tournefort, first in France and then on the renowned journey he made to the Levant. After his return he worked up his drawings and since he was well acquainted with botanical requirements they remained for many years of considerable use to botanists. His paintings, contrasting with those of Robert, are executed in opaque colour and are of sharply defined form, often being highly decorative.

Although their works rarely achieved the heights of the French artists of the seventeenth century, notable florilegia were also made in that century by artists in Holland, Germany and England. One was the work of Pieter van Kouwenhoorn, made in the first half of the century, the plants in it being painted in body-colour and depicted with great accuracy of detail. A similar work was made at Leeuwarden by P. F. de Geest about 1650. After the Thirty Years War Johann Walther the Elder painted a very attractive florilegium of the plants of the garden of Count Johann of Nassau at Idstein near Frankfurt-am-Main. In 1720 Johann Simula made a florilegium for Count Johann of Dernatt rather like that of Walther but somewhat inferior to it: nevertheless he painted well apart from difficulties with perspective and a lack of interest in foliage, and shows his succulents in decorative Chinese pots. There were other similar German florilegia. The Royal Library at Windsor contains two volumes of the paintings of Alexander Marshall which also date from this time. These are botanical notebooks, the well-executed paintings of more than a thousand flowers on 159 sheets being placed on the pages without any attempt at design. Two other florilegia of the late seventeenth and early eighteenth centuries are preserved in England. That of Everhardus Kickius, a Dutchman, was made for the Duchess of Beaufort in 1703–5 and is still at the Beaufort family house at Badminton. It depicts life-size 68 plants grown on the estate and is beautifully executed in colours still fresh and bright. The other is a collection held by the Royal Society of about 40 watercolours, half of which are of grasses, by Richard Waller, who was Secretary of the Society. These, too, are competently and sensitively drawn.

The intense interest which the people of the Netherlands have always taken in flowers gave birth to the famous school of flower-painting which flourished in the Low Countries in the seventeenth and eighteenth centuries. These paintings were executed, of course, purely for the joy of de-

A Christmas Rose by Nicolas Robert from *Diverses Fleurs* (c. 1660). Robert was a painter of great range and brilliance who had a long and successful career. It is said that he was persuaded by Robert Morison, the Scottish botanist, to work for the Duke of Orleans at Blois, where he produced much of his finest work.

Basil Besler displayed a real sense of design in his magnificent *Hortus Eystettensis*, the plants being arranged very decoratively and treated in splendid fashion so that the effect is very impressive, rivalling, when coloured, the later Thornton's *Temple of Flora*. Botanical accuracy, however, suffered by being subordinated to decorative considerations.

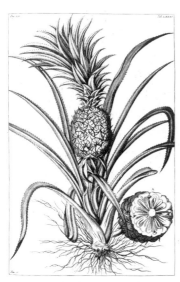

A pineapple from Georg Everard Rumph's *Herbarium Amboinense* (1741-55), a work of immense botanical importance.

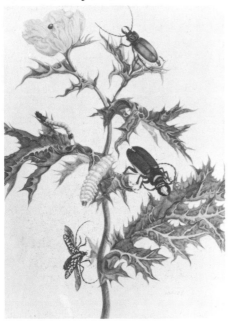

An engraving after a drawing by Maria Sybille Merian of *Cardus spinosus* with insects and caterpillars.

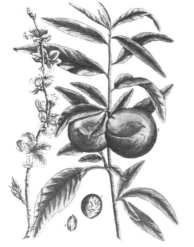

A peach tree from Elizabeth Blackwell's *A Curious Herbal*.

picting beautiful things, but the school touched the field of botanical illustration because a number of the artists, such as those of the van Huysum and van der Vinne families, were drawn into such work. Much was also done in the Dutch colonies in the second half of the seventeenth century where artists illustrated such works as the *Herbarium Amboinense* of Georg Everard Rumpf and the *Hortus Indicus Malabaricus* of Van Rheede tot Draakestein, published in 1741-55 and 1678-1703 respectively, both very large works, basic in their field, furnished with accurate and competent engravings. Paul Hermann's paintings in monochrome of Ceylon plants were used by Linnaeus and Englebert Kaempfer made good drawings of the plants he encountered in his travels in Persia and Japan. An artist whose style derived from the Dutch school of flower-painting was Maria Sybille Merian, of mixed Swiss-Dutch origin, who painted plants upon which insects fed. She was primarily an entomologist and published three volumes on European insects in 1679, 1683 and 1717 respectively. She also spent some time in Surinam, publishing a similar work on the insects of that country in 1705. Although her paintings of flowers are rarely executed with the perfection of those of her insects, her gifts were such that they are still very good. She used very fine lines and transparent colour, making her shadows by intensifying the colour.

Some printed books of this period that deserve mention because of the quality of their drawings are Jacob Breyne's *Exoticarum Plantarum* (1678-89), some of the small plates in which are excellent, the artist being Andreas Stech; Jan Commelin's *Horti Medici Amstelodamensis* ... (1697-1701), the hand-painted engravings in which are rather inferior in quality to the original paintings by Johan and Maria Moninckx from which they were made; and Johann Christoph Volckamer's *Nürnbergische Hesperides* (1708-14), which contained uncoloured plates of fruit set against a background of views of gardens and palaces. One of the van Huysum family, Jacobus, illustrated John Martyn's *Historia Plantarum Rariorum* (1728-36), his drawings being engraved and reproduced by a crude method of mezzotint, noteworthy because it was the first attempt of its kind. He also illustrated the *Catalogus Plantarum* (1730) in a similar way including also hand-coloured etched plates. Both these works, designed to bring new plants into notice, were issued by the Society of Gardeners, an association of nurserymen. Neither project was successful, though they have been much praised. Robert Furber, a Kensington nurseryman, produced in 1730 his own seed catalogue, entitled *Twelve Months of Flowers*, illustrated with 12 large hand-coloured engravings from paintings by the Flemish artist Pieter Casteels. Johann Jakob Dillenius drew and etched his own figures for his *Hortus Elthamensis* and *Historia Muscorum*, published in 1732 and 1741 respectively. He took great pains to be accurate and his work was of great use to later botanists. Mrs Elizabeth Blackwell's *A Curious Herbal* (1737-39), drawn from plants in the Chelsea Physic Garden, enjoyed considerable success and was re-issued with re-engraved plates in 1757-73 by Trew of Nuremberg, but the hand-coloured etchings were of mediocre standard only. The eight folio volumes of Johann Weinmann's *Phytanthoza Iconographia* (1737-45) contained over a thousand hand-coloured engravings for many of which the early crude method of mezzotinting was used. A number of books published in Germany in the eighteenth century were illustrated by 'nature printing', a process in which, by various methods, a plant itself could be made to imprint an impression on the paper.

George Dionysius Ehret stands head and shoulders above his contemporaries in the middle of the century. Born in Heidelberg in 1708, he learnt his profession in Germany and came to England to settle permanently in 1736. Thereafter he produced a steady flow of superb paintings until his death in 1770. By 1750 he was being lionised by the nobility and was greatly in demand as a tutor. He preferred working on vellum and in body-colour rather than wash, his work being ideally balanced between the fidelity required by the scientist and the promptings of his own feelings for colour and design, so that he pleases both botanists and artists. His strength lay in his sureness of touch, force of handling and marvellous sense of design.

He made the engravings of some of his work used for books but, although he was in demand for this as well, it does not rank in quality with his paintings.

Other fine artists of the mid and later eighteenth century working in England were Johann Sebastian Müller from Nuremberg, his son John Frederick Miller, Gertraud Metz, Peter Brown and Simon Taylor, the last two painting in Ehret's style. William King of Totteridge and James Bolton, two other English artists, were competent workers, and Sydney Parkinson, who was artist on Captain Cook's first voyage to the South Seas (1768–72) and died on the voyage, left many drawings of considerable beauty. T. Robins, of whom nothing is known, also left an album of over 100 paintings of high quality executed with a technique resembling that of later artists, so that his work looks almost modern. Sir John Hill, a picturesque character of whom Dr Johnson said he was 'an ingenious man, but had no veracity', produced a great number of books, many on plants, but although the plates were often decorative, they do not rank high as botanical illustrations. Although hardly scientific, the coloured paper mosaics produced by Mrs Mary Delany at this period were much praised.

In France, Madeleine Basseporte succeeded Claud Aubriet and maintained, until she aged, an acceptable standard. Some advance was made in colour illustration, one French work attempting to overcome the problems of printing by using several plates to apply different colours, while another made use of a process which would print three colours at the same time, but results were crude. Joseph Pierre Buc'hoz was responsible for many large works on plants but included little that was original except some drawings of Chinese plants by native artists. The numerous works of Nikolaus Joseph Jacquin produced in Vienna were of greater importance, some of them being illustrated by plates of the highest standard, the work of Franz von Scheidel. The *Flora Danica* (1761–1871) produced in Copenhagen and illustrated by several artists, and five German works, Schmidel's *Icones Plantarum* (1762), Johann Kerner's *Figures des Plantes Economiques* (1786–96) and *Hortus Sempervirens* (1795–1830), J. Mayer's *Pomona Franconica* (1776–1801) and Georg Knorr's *Thesaurus* (1780) all have plates worthy of mention. Holland, Hungary and Italy also produced their share of such works and two noteworthy collections of botanical drawings were made in Spanish colonial possessions, that of José Celestino Mutis in Colombia and that of Sessé and Mociño in Mexico. William Bartram, son of John Bartram, the first native American botanist, made studies of plants in Carolina and Virginia, one of the first Americans to make such drawings.

Gerard van Spaëndonck succeeded Madeleine Basseporte and produced watercolours of the finest quality. His pupil, Pierre-Joseph Redouté, is more famous because he had greater opportunities, but his work did not excel that of his master. The technique was the same, pure watercolour, subtly graded, with a sparing use of body-colour to suggest sheen. The works of both masters are outstandingly beautiful. For engravings of his works in books such as *Les Roses*, the high effective stipple method was used which involved etching by dots instead of by lines and Redouté was lucky in having the services of engravers who were masters of their craft. The excellence of his work made it universally renowned, but there were several artists who worked under him or van Spaëndonck who based their technique on that of the latter and could have been Redouté's equals had they had his opportunities, among them Pierre Jean François Turpin, Pierre-Antoine Poiteau, Pancrace Bessa and Madame Vincent.

In England, William Curtis founded the *Botanical Magazine* in 1787, a work which still continues to be published and has been served by a succession of fine artists since its inception, including James Sowerby, Sydenham Edwards in the early years, William Jackson Hooker for ten years, then Walter Hood Fitch through 43 years of Victorian times and Lilian Snelling, Stella Ross-Craig and Margaret Stones in modern times. Contemporary with Redouté was Robert John Thornton, whose *Temple of Flora* was splendid and spectacular both in size and renown, being illustrated with 28 large plates, mainly by Peter Henderson and Philip Reinagle. Some of

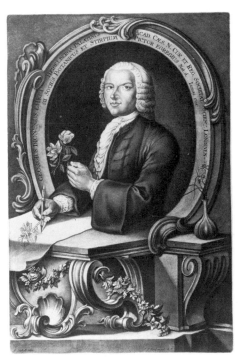

George Dionysius Ehret, the greatest botanical painter of the eighteenth century – perhaps of all time.

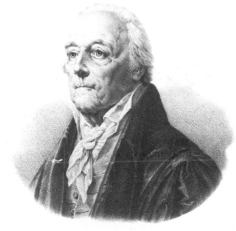

Nicolas Joseph Jacquin, editor of many lavishly illustrated botanical books.

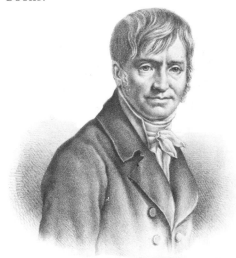

Pierre-Joseph Redouté, most famous for his portraits of roses in *Les Roses*.

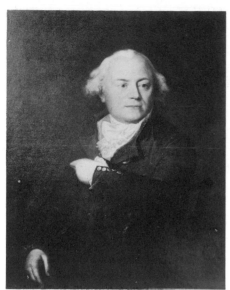

Francis Bauer (1758–1840) produced, during his 50 years at Kew, a long succession of the most beautiful botanical drawings ever made.

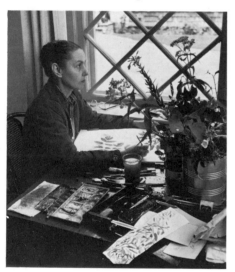

The botanical illustrator, Anne Ophelia Dowden (1907–) at work. She grew up in Boulder, Colorado, spending her childhood in the foothills of the Rockies where she acquired the first-hand knowledge of nature which has since served her so well in portraying plants.

the plates are in mezzotint and some in aquatint, and some in a mixture of both, printing being done in basic colours and then finished with water-colour washes. Contemporary also were the many fine drawings of Indian artists made for William Roxburgh, some of which were reproduced in *Plants of the Coast of Coromandel*, and for Nathaniel Wallich and others. This was also the age of the brothers Ferdinand and Francis Bauer, both artists of immense ability. Ferdinand illustrated John Sibthorp's *Flora Graeca* but, disappointed in the cessation of publication of the *Illustrationes Florae Novae Hollandiae* recording the plants of Matthew Flinders' voyage to Australia in the *Investigator*, on which he had sailed as artist with Robert Brown as botanist, he returned to his native Austria. Francis worked for Sir Joseph Banks and settled permanently at Kew, becoming a highly skilled botanist in his own right, famous for microscopic drawings as well as flower studies.

Illustrations of a high standard continued to be produced in England and France during the nineteenth century and to a lesser extent elsewhere. Lithography came in shortly after the turn of the century but declined after 1850 when inferior work began to be produced and it began to be imagined that the new invention, photography, would supersede it. Walter Hood Fitch continued to produce fine lithographic work until the 1870s and his nephew continued the same standard until the 1920s. Chromolithography began to be used but proved very inferior as a method of reproduction. In the 1880s the wheel once again came full circle as it had done with the use of stone – originally used for carving, then, over 3,000 years later, in lithography – and the woodcut was revived, first as a rival to photography and then as a fine vehicle for a new era of botanical illustration by woodcut. There were many artists of note during the century, among whom were Mrs Edward Bury who illustrated *A Selection of Hexandrian Plants*, Mrs Withers, who illustrated a number of books including, with Miss Drake, the very large *Orchidaceae of Mexico and Guatemala*, George Maw, who illustrated his *Genus Crocus* with drawings described by Ruskin as 'quite beyond criticism', Henry Moon, whose technique has been much copied and Alfred Parsons, whose delicate illustrations for Miss Ellen Willmott's *The Genus Rosa* were spoiled in reproduction by the use of chromolithography. In France, Alfred Riocreux achieved a place something like that of Fitch in England and there were a number of other capable artists carrying on the standards of Redouté. American artists of ability were Charles Edward Faxon, who illustrated a number of books in the latter part of the nineteenth century, Florence McKeel and Blanche Aimes.

In the twentieth century the number of illustrated botanical works has greatly multiplied and colour photography has entered the field. Wilfrid Blunt, the author of the definitive book on botanical illustration, wrote, 'it must, perhaps, for ever remain an open question as to who was the greatest botanical artist of all time, though I myself would unhesitatingly give first place to Francis Bauer . . . the last hundred years can show no artist of the calibre of either of these two brilliant brothers [Francis and Ferdinand Bauer]'. That verdict was rendered 30 years ago. Since that time a number of new artists of ability have arisen, including, in England, Mary Grierson and the Australian-born Margaret Stones and, in the USA, Anne Ophelia Dowden. Wilfrid Blunt ended his book by saying 'it can hardly be doubted . . . that the great days of botanical art lie behind us and that, in the future, flower-drawing will become little more than a by-product of science or a relaxation in art.' I do not know whether he continues to hold that view, but I would venture to suggest that he was too pessimistic, and that the art of botanical illustration has never been healthier.

BIBLIOGRAPHY

BLUNT, Wilfrid, *The Art of Botanical Illustration* (Collins, London, 1950; Charles Scribner's Sons, New York, 1951)

BLUNT, Wilfrid, *Flower Books and their Illustrators* (Catalogue of National Book League, London, exhibition; Cambridge University Press, 1950)

BLUNT, Wilfrid and SITWELL, Sacheverall, *Great Flower Books 1700–1900* (Collins, London, 1956)

CALMANN, Gerta, *Ehret : Flower Painter Extraordinary* (Phaidon Press, London; New York Graphic Society, Boston, 1977)

CHEWNING, Emily Blair, *The Illustrated Flower* (Harmony Books, New York; Omnibus Press, London, 1977)

COATES, Alice M., *The Book of Flowers* (Phaidon Press, London, 1973)

COATES, Alice M., *The Treasury of Flowers* (Phaidon Press, London; McGraw Hill, New York, 1975)

DUNTHORNE, Gordon, *Flower and Fruit Prints of the 18th and early 19th centuries* (Dulau, London, 1938; Da Capo, New York, 1970)

HENREY, Blanche, *British Botanical and Horticultural Literature before 1800* (Oxford University Press, 1976)

HUNT BOTANICAL LIBRARY, Carnegie Institute of Technology, Pittsburgh, *Catalogue of an Exhibition of Contemporary Botanical Art and Illustration* (1974)

HUNT BOTANICAL LIBRARY, Carnegie Institute of Technology, Pittsburgh, *20th Century Botanical Art and Illustration* (1969)

HUNT INSTITUTE FOR BOTANICAL DOCUMENTATION, Carnegie-Mellon University, Pittsburgh, *Artists from the Royal Botanic Gardens, Kew* (1974)

KING, Ronald, *The World of Kew* (Macmillan, London, 1976)

MANNERING, Eva (ed.), *Flower Portraits* (Ariel Press, London, 1961)

MUSEUM MEERMANNO-WESTREENIANUM, *1000 jaar bloem-illustratie* (Exhibition catalogue, The Hague, 1966)

NATIONAL LIBRARY OF SCOTLAND, *Botanical Illustration* (Exhibition catalogue, Edinburgh, 1964)

NISSEN, Claus, *Die Botanische Buchillustration* (Hiersemann, Stuttgart, 1951, 1966)

SINGER, C., 'The Herbal in Antiquity and its transmission to later ages', in: *Journal of Hellenic Studies*, 47 (1927)

SOCIETY OF HERBALISTS, *Exhibition of Flower Books* (Exhibition catalogue, London, 1953)

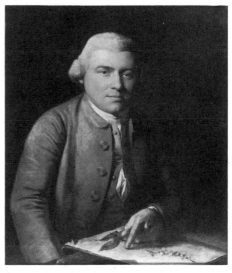

William Curtis holding his famous book, *Flora Londinensis* (1777-98). A portrait attributed to Joseph Wright of Derby.

Acknowledgements

The author and publishers are grateful to Professor J. P. M. Brenan, Director of the Royal Botanic Gardens, Kew and to Mr V. T. H. Parry, Chief Librarian and Archivist of the Royal Botanic Gardens, for permission to use the resources and facilities of the Library of the Royal Botanic Gardens.

They would also like to acknowledge the designer, Malcolm Smythe, and Angelo Hornak for the special photography required.

Thanks are also due to those institutions and individuals who supplied illustrations.

COLOUR PLATE CAPTIONS

(All plates from works in the Library of the Royal Botanic Gardens, Kew, unless otherwise stated)

Plate 1
This drawing from the *Codex Vindobonensis* (AD 512) which contains portraits of the plants in the *De Materia Medica* of Pedacius Dioscorides is a clearly recognizable picture of a rose bush, and shows that the standard of plant drawing in this ancient work was much superior in realism to almost anything to be found in later works before the sixteenth century. (Österreichische Nationalbibliothek)

Plate 2
This delicate and sensitive study entitled 'Das Grosse Rasenstück' ('The Great Piece of Turf') was painted in 1503 by the famous German artist Albrecht Dürer (1471–1528) and is one of a number of botanical drawings he made. It is remarkable not only for being the first ecological study but for the immense precision of the drawing which makes each plant portrayed an authentic representation while all are brought together naturally to make a superb work of art. (Albertina, Vienna; Photo: The Cooper–Bridgeman Library)

Plate 3
This realistic watercolour drawing of 'Lichnis Calcedonica' (*Lychnis chalcedonica*) was painted by Giacomo Ligozzi (*c.* 1547–1626) who was court painter to the Medici and Superintendent of the Uffizi Gallery in Florence. He was famous in his day for works other than those of plants but the latter are, as is evident from this specimen, original paintings of very high quality. (Uffizi Gallery, Florence, Gabinetto Disegni; Photo: Scala)

Plate 4
These hand-coloured engravings of irises, *Iris susiana* and two varieties of *Iris bisantina*, are from Emanuel Sweert's *Theatrum Florae* (1612) which, although called a florilegium and produced at the behest of Emperor Rudolf II, for whom Sweert at one time worked, was really a sale catalogue. The plate is typical of the occasionally inferior work which filled the pages of the imitators of Pierre Vallet's *Le Jardin du très Chrestien Henry IV* (1608).

Plate 5
Johann Walther's florilegium, which is in the Victoria & Albert Museum, was painted in the mid-seventeenth century for Count Johann of Nassau at Idstein, near Frankfurt-am-Main. Although not quite the equal of the best work his paintings and, indeed, the whole work, evoke very strongly the age they unconsciously portray. The pose of the flowers in this watercolour drawing of carnations is not naturalistic, but the whole picture is impressive and beautiful. (Victoria & Albert Museum, London; Photo: Michael Holford Library)

Plate 6
Alexander Marshall's paintings in the Royal Collection are in the form of a botanical notebook, the plants having no formal arrangement. They are, however, skilfully executed and often very pleasing, as in this painting where, in addition to the little forget-me-not in the corner, the artist has portrayed a fallen blossom as well as the formal spray of *Rosa provincialis*. The collection was painted *c.* 1659, the year shown on the only dated drawing. (Reproduced by Gracious Permission of Her Majesty The Queen)

Plate 7
An original watercolour drawing (*c.* 1680) by Nicolas Robert (1614–85) of the Common Sunflower (*Helianthus annus*), one of the first north American annual flowers to be introduced into European gardens, where the large size and splendour of its deep yellow flowers with brown centres soon gained it a permanent place. This superb painting captures completely the majesty of the flower, a fitting illustration for the reigning monarch, Louis XIV, the Sun King. (Musée d'Histoire Naturelle, Paris; Photo: Photographie Giraudon)

Plate 8
This splendid and impressive study of *Helleborus kochii*, a watercolour drawing by Claud Aubriet (1665–1742) is a fine example of this artist's work which, in its sharpness of definition seems to have some of the quality of medieval illumination. Aubriet worked closely with de Tournefort and other French botanists of his day and his work shows, in its attention to structure, a consciousness of the needs of botanical science. (British Museum (Natural History), London)

Plate 9
The *Historia Plantarum Rariorum* (1728–36) of John Martyn, Professor of Botany at Cambridge, which depicted a number of new plants in the Chelsea Physic Garden, was illustrated by Jacobus van Huysum, younger brother of the famous Dutch flower painter, the drawings being engraved by E. Kirkall and printed in a kind of crude mezzotint, the first attempt of its kind. This engraving of two varieties of *Turnera frutescens* has been touched with watercolour to produce a not unpleasing result.

Plate 10
This undated watercolour on vellum of the well-known climber *Bignonia americana*, the 'Trumpet Flower', by Georg Dionysius Ehret (1708–70) is one of the most attractive of this artist's works in the Victoria & Albert Museum. Although possibly an early work, it shows a high skill in the disposition of the parts and in the execution while still portraying a plant spray in a natural attitude. (Victoria & Albert Museum, London; Photo: Angelo Hornak)

Plate 11
Very popular in its time, the plates being often reproduced, Robert Furber's *Twelve Months of Flowers* (1730) was illustrated by twelve hand-coloured engravings by H. Fletcher from paintings by the Flemish artist Pieter Kasteels. Each plate represents a month of the year, the one shown being that for September. They are executed in the manner of a Dutch flower-piece to show the plants of the month in bloom. (Victoria & Albert Museum, London; Photo: Angelo Hornak)

Plate 12
This 'Still Life of Fruit and Flowers' by Jan van Huysum, painted in 1736–7, shows the superlative excellence which the Dutch school reached in this kind of oil painting. Everything is so realistically painted that it appears alive. The composition is, however, unreal: narcissi do not flower in nature when grapes are ripe. They could, of course, have been forced but these paintings were, in fact, not made directly from life, but assembled from studies. (Reproduced by courtesy of the Trustees, The National Gallery, London)

Plate 13
Christoph Jakob Trew (1695–1769) published a number of finely illustrated botanical books, among them *Plantae Rariores* (1763). Included in this work was this hand-coloured illustration of *Pentapetes phoenicia*, which was drawn and engraved by Jakob Christoph Keller, Professor

of Drawing at Erlangen University. It is a good example of the manner in which botanical artists often colour only essential parts of a drawing so that detail is not obscured, the uncoloured part creating a pleasing 'shadow' effect behind the coloured portion.

Plate 14
William Curtis (1746–99) used several artists to execute the illustrations for his *Flora Londinensis* (1775–87) which described and depicted the plants which grew wild within ten miles of the metropolis. This hand-coloured illustration of *Galeopsis versicolor* engraved by Sansom was drawn by Sydenham Teast Edwards (?1769–1819), the artist who drew most of the plates for the early issues of the *Botanical Magazine* which Curtis started in 1787 and which is still published.

Plate 15
Mrs Delany, who moved in the upper ranks of English society in George III's court, took up as a pastime at the age of 72 the making of mosaic pictures of plants from coloured paper, achieving such success at it that Sir Joseph Banks said he would be able 'to describe botanically any plant from Mrs Delany's imitations'. The specimen shown is that of *Rosa gallica*. The mosaics are curiosities rather than of botanical significance. (Courtesy of the Trustees of the British Museum)

Plate 16
Nikolas Joseph Jacquin (1727–1817), of Dutch origin, one of the leading chemists and botanists of his time, produced many lavishly illustrated books, among them *Icones Plantarum Rariorum* (1781–95). This hand-coloured etching of *Lychnis grandiflora* was executed and engraved by members of the team of capable artists he collected around him at Schönbrunn, near Vienna, which included Joseph Hofbauer, Ferdinand and Francis Bauer and Joseph Scharf. The transparent colouring with the lines showing through is held to be a fault in this work.

Plate 17
An original watercolour drawing (*c.* 1784) by Gerard van Spaëndonck (1746–1822) of *Gordonia lasianthus*, a small north American tree with attractive white flowers introduced into Europe in the first half of the eighteenth century. Van Spaëndonck was Pierre-Joseph Redouté's teacher and the originator of the techniques that Redouté used so successfully. This splendid and highly finished example of van Spaëndonck's work shows that his virtuosity fully equalled that of his more famous pupil. (Musée d'Histoire Naturelle, Paris; Photo: Photographie Giraudon)

Plate 18
James Sowerby (1757–1822) attempted in his *Flora Luxurians* 'to display the Beauties of Nature'. This hand-coloured engraving from that work showing a tulip variety named Peregrinus Apostolicus exhibits one of the more bizarre of those beauties. As the plate shows, Sowerby was an artist of high calibre, the peak of his achievement being his *English Botany* in 36 volumes (1790–1814) the text of which was by the famous botanist, Sir James Edward Smith.

Plate 19
William Roxburgh (1751–1815) of the Calcutta Botanic Garden accumulated a large number of botanical drawings by native Indian artists, some of which he used to illustrate his *Plants of the Coromandel Coast* (1795–1819), one of the most impressive publications of its time. This striking hand-coloured engraving of one of these plates depicting *Bombax heptaphyllum*, shows the fine standard which these mostly anonymous artists reached.

Plate 20
Francis Bauer (1748–1840), German by birth, adopted England as his country in 1790 when, accepting an offer of employment by Sir Joseph Banks, he settled at Kew. This well-engraved hand-coloured plate of *Erica sebana* from William Townsend Aiton's *Delineations of Exotic Plants* (1796) shows his strength as a draughtsman. Francis Bauer, who worked much with the microscope, has strong claims to be regarded as the finest botanical artist of all time.

Plate 21
Robert Thornton's *Temple of Flora* (1799–1807) is one of the most famous of all florilegia and this magnificent mezzotint, finished in hand-colour, of the 'Night Blowing Cereus' ('Night-flowering Cactus'), is one of its most striking illustrations. The picture is a composite one, the plant being painted by Philip Reinagle (1749–1833) and the moonlight added by Abraham Pether (1756–1812). Much of the impressiveness of the illustrations in this work derives from the settings in which the plants are placed by the artists.

Plate 22
Although published primarily for use by designers and manufacturers of china, *toiles*, chintzes and other fabrics, Jean Louis Prevost's *Collection des Fleurs et des Fruits* (1805) was a superb production, the printing of the work exploiting the technique of stippled engraving, printed in colour, to the full. This illustration of *Pavots doubles* (double poppies) demonstrates the marvellous splendour and freshness of the work, which shows Prevost to have been an artist of the highest skill. (By Permission of the British Library)

Plate 23
A painting of hibiscus made *c.* 1807 by a Chinese artist in Canton remarkable not only for the way in which the artist has combined the fidelity with which the flower spray is drawn with a slightly stylised Chinese pose but also for the realism of the grasshopper and the butterfly that he has incorporated into his picture, making it of interest to entomologists as well as botanists. (India Office Library, London)

Plate 24
Ferdinand Bauer, brother of Francis, accompanied the botanist Robert Brown and Captain Matthew Flinders on their famous voyage to and round Australia in 1801–4, when almost a quarter of the plant species indigenous to Australia were collected. A few of the thousands of drawings he made on the voyage were etched by himself for *Illustrationes Florae Novae Hollandiae* (1813). This striking hand-coloured etching of *Banksia coccinea* is from this work.

Plate 25
This stipple engraving, printed in colour and retouched by hand, of a variety of rose derived from *Rosa damascena*, taken from the famous *Les Roses* (1817–24) by Pierre-Joseph Redouté, demonstrates his skill and that of his engravers in capturing these exquisite flowers for the printed page. The age of Redouté was a notable time in French botanical art as several of his pupils and contemporaries were his equal in skill.

Plate 26
William Hooker (1779–1832), not to be confused with his more famous contemporary, the botanist Sir William Jackson Hooker, was official artist to the Horticultural Society of London (now the Royal Horticultural Society). This very precise and carefully coloured aquatint of a 'Galande Peach' from his *Pomona Londinensis* (1818), a work describing 'the most esteemed Fruits cultivated in British gardens', shows that he was an artist of considerable capacity, prints such as this one being among the finest fruit prints ever made.

Plate 27
Samuel Curtis's *Monograph on the Genus Camellia* (1819), illustrated by Clara Maria Pope (d. 1838), was one of the largest botanical works of its time, competing with Thornton's *Temple of Flora*. The group of camellias in this attractive very fine-grained aquatint from that work shows that she was an able artist who could effectively compose and paint a large group of flowers. The glaze on the colouring is notably heavy, especially on the leaves.

Plate 28
A Passion-flower from a drawing by Pierre Jean François Turpin (1775-1840) *c.* 1819-20 for *Leçons de Flore* by Turpin and J. C. M. Poiret. Turpin had little formal training but possessed great natural ability, his drawings of botanical details being among the best ever made. He collaborated with the botanist Pierre-Antoine Poiteau in illustrating some of the most important botanical works of the early nineteenth century. (The Lindley Library, The Royal Horticultural Society, London; Photo: John Webb)

Plate 29
Vishnupersaud was one of the Indian artists who worked for Nathaniel Wallich (1786-1854) who followed William Roxburgh (1751-1815) at the Calcutta Botanic Garden. This hand-coloured lithograph of a fine study of *Cuscuma cordata* made by Gauci after a drawing by Vishnupersaud and reproduced from Wallich's *Plantae Asiaticae Rariores* demonstrates very well the skill these Indian artists brought to their work and their subtlety in presentation.

Plate 30
The large-scale *Selection of Hexandrian Plants* (1831-4) by Mrs Edward Bury is one of the great flower folios of its time, and was highly acclaimed. Mrs Bury, an amateur without scientific training, was anxious only to present the beauty of 'a particularly splendid and elegant tribe of plants'. Her painting of *Lilium tigrinum* (the 'Tiger Lily'), engraved for the book in fine-grained aquatint, partly printed in colour and retouched by hand by R. Havell, shows how effectively she went about her task.

Plate 31
This charming lithograph of the orchid *Stanhopea martiana* comes from James Bateman's giant folio describing and illustrating *The Orchidaceae of Mexico and Guatemala*. The original painting was by Mrs Withers, but M. Gauci, the lithographer, was such a master of his craft, and the hand-colouring has been done so skilfully that there is little to choose between the original and the reproduction. The illustrations in this book are masterpieces of Victorian printing art.

Plate 32
Little is known about Marie Anne (active *c.* 1840), who may have been one of Pierre-Joseph Redouté's royal pupils, but, although her work was decorative rather than scientific, she maintained the high standard set by French botanical artists in the early nineteenth century. This well composed and faithfully executed group of dahlias, which is in the Victoria & Albert Museum, demonstrates her considerable artistic abilities. (Victoria & Albert Museum, London; Photo: Angelo Hornak)

Plate 33
Walter Hood Fitch (1817-92) drew and lithographed nearly 10,000 plants in his lifetime and illustrated many books, among them those which gave an account of plants encountered by Sir Joseph Hooker on his expedition to the Himalayas (1848-52). This illustration of *Quercus lamellosa* from *Illustrations of Himalayan Plants* (1855) shows Fitch's faultless draughtsmanship in a subject where showy flowers do not distract the attention.

Plate 34
For a time in the second half of the nineteenth century chromolithography was used as a method of reproduction for printing botanical plates, but results were often far from satisfactory. This illustration of *Carica papaya* from Berthe Hoola van Nooten's *Fleurs, Fruits et Feuillages . . . de l'Île de Java* (1863) shows one of the better productions in which the method was used.

Plate 35
The American artist Isaac Sprague (1811-95) has the distinction of having served in 1843 as assistant to the renowned John James Audubon on an ornithological expedition up the Missouri River. This lithographed drawing of the Wild Orange-Red Lily (*Lilium philadelphicum*) comes from Professor George L. Goodale's *Wild Flowers of America* (New York 1877-81) which was illustrated by 50 colour plates drawn by Sprague. (Courtesy of The Hunt Institute, Carnegie-Mellon University, Pittsburgh, Pennsylvania)

Plate 36
This delicate watercolour drawing of *Kalmia latifolia*, the Calico Bush, by Frederick Andrews Walpole (1861-1904) is an excellent example of this American artist's refined and elegant work. The exquisite fineness, together with absolute realism, that he achieved in his paintings sprang in part from his unusual technique of ink drawing in which he used a sable brush reduced to a few hairs held almost parallel to the paper to draw his lines. (Courtesy of The Hunt Institute, Carnegie-Mellon University, Pittsburgh, Pennsylvania)

Plate 37
An original watercolour made *c.* 1910 by Alfred Parsons (1847-1920) for Ellen Wilmott's *The Genus Rosa* (John Murray, London, 1914). This beautiful many-petalled rose was the only yellow rose in cultivation in the British Isles until the end of the eighteenth century, but it was not wholly satisfactory as a garden flower because it preferred a drier and warmer climate and the flowers often rotted off without opening in the wet. (The Lindley Library, The Royal Horticultural Society, London; Photo: John Webb)

Plate 38
In the long train of distinguished botanical artists who have served Curtis's *Botanical Magazine* since it was first published in 1787, Lilian Snelling (1879-1972), who was principal artist for thirty years in the first half of the twentieth century, has an honoured place. She also illustrated Grove and Cotton's *Supplement to Elwes' A Monograph of the Genus Lilium* (1934-40) from which this impressive plate of *Lilium centifolium* is taken, amply demonstrating her talents both as artist and lithographer.

Plate 39
The American artist Anne Ophelia Dowden (1907-) did not begin her artistic life as a botanical illustrator but as soon as she entered the field in the early 1950s it was evident that someone supremely talented had come upon the scene. This watercolour of the Tree Peony (or Moutan), hitherto unpublished, needs no words to explain its virtues. The flowers come alive off the page in a way few artists can achieve. (Courtesy of the artist)

Plate 40
Mary Grierson (1912-) is a distinguished contemporary artist who for a time served as official artist to the Royal Botanic Gardens, Kew and has painted threatened plants for the World Wildlife Fund. Her designs were also featured in 1967 on British postage stamps. The splendid watercolour of *Iris foetidissima* reproduced here shows that she need not fear comparison with masters of the past. (Courtesy of the artist; Photo: Spink & Son Ltd)

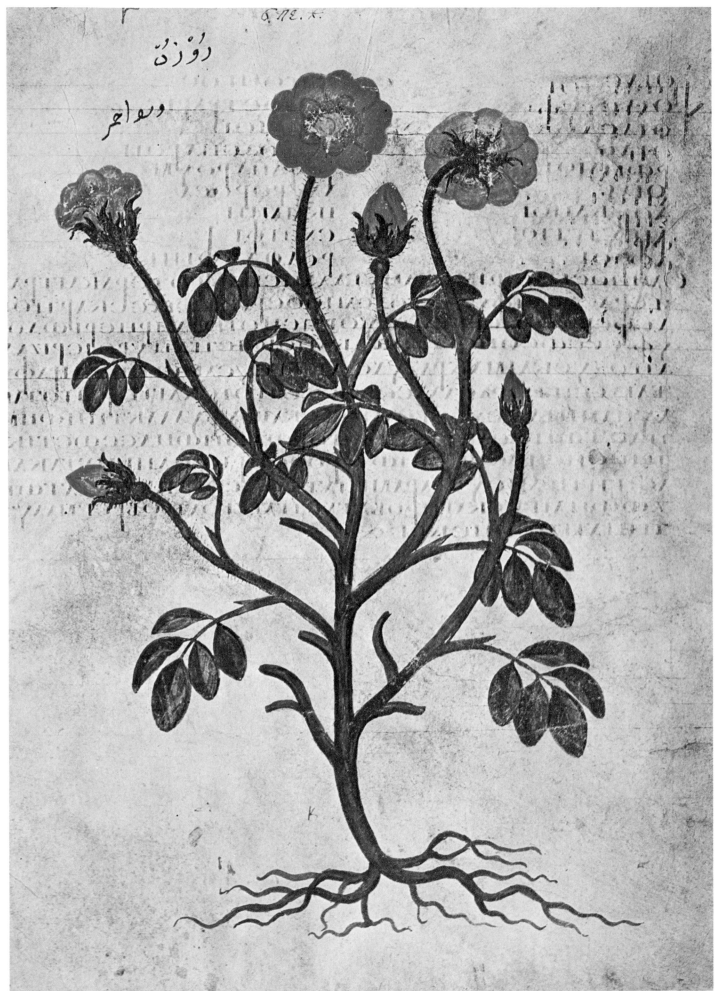

1

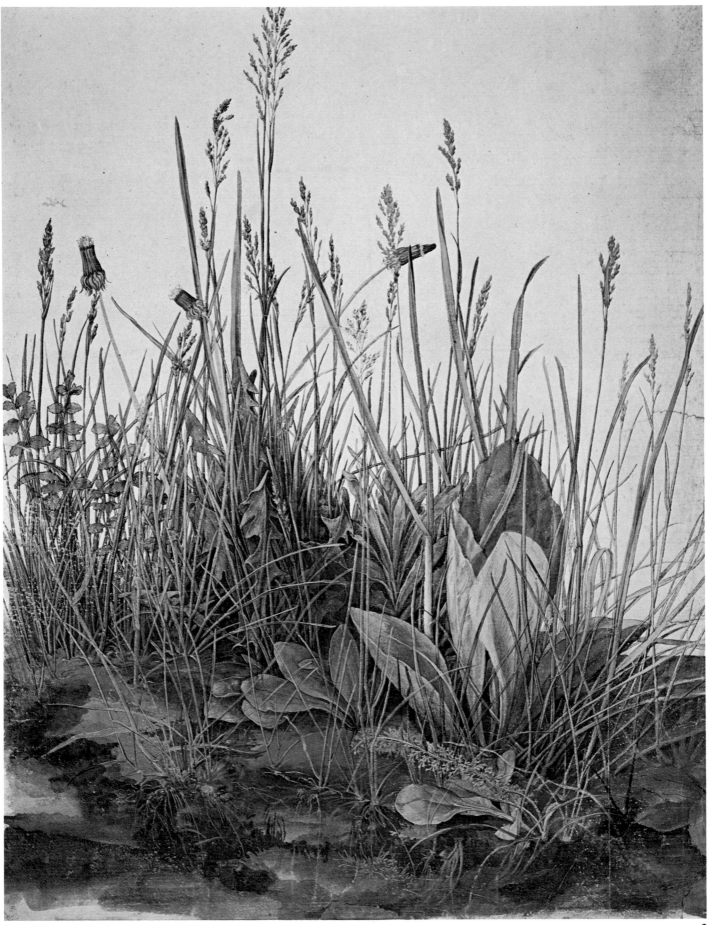

2

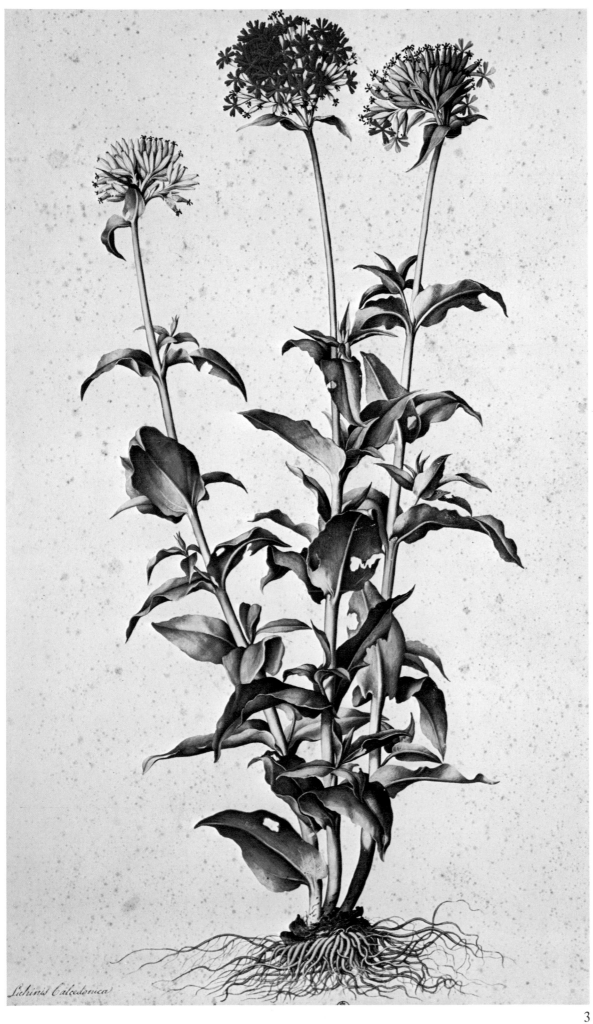

Lichnis Calcedonica

3

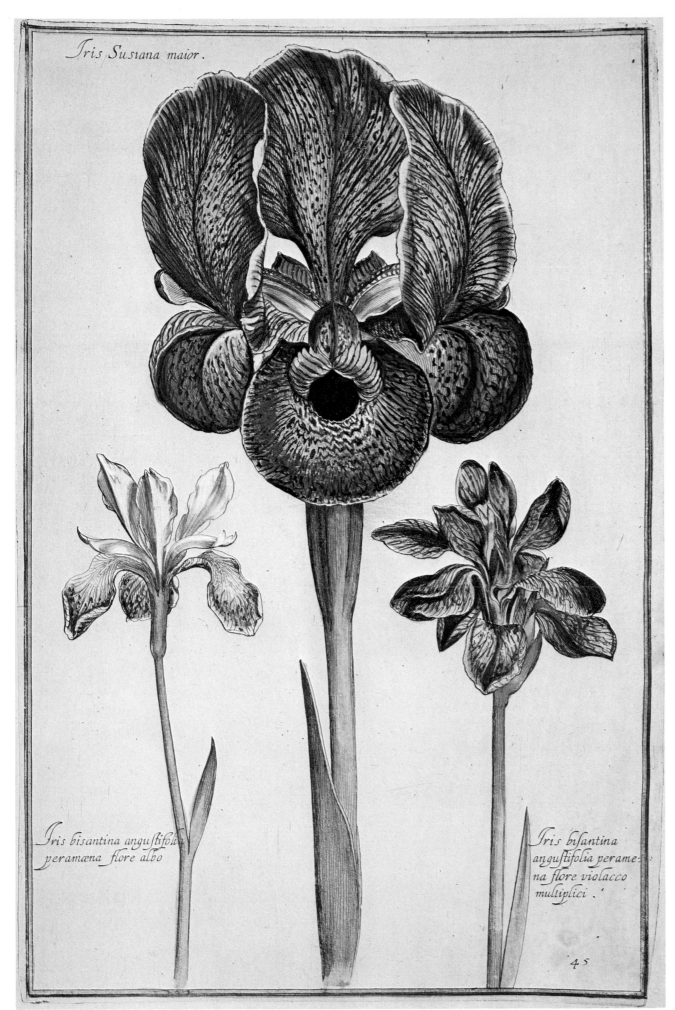

Iris Susiana maior.

Iris bisantina angustifolia peramœna flore albo

Iris bisantina angustifolia peramena flore violacco multiplici.

45

4

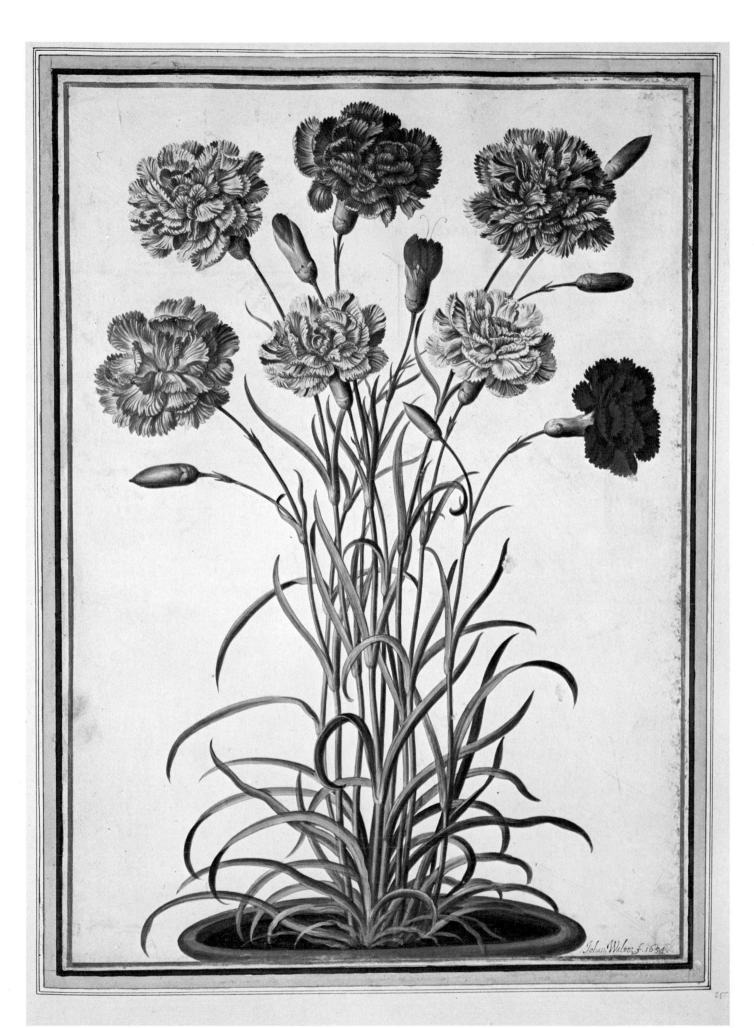

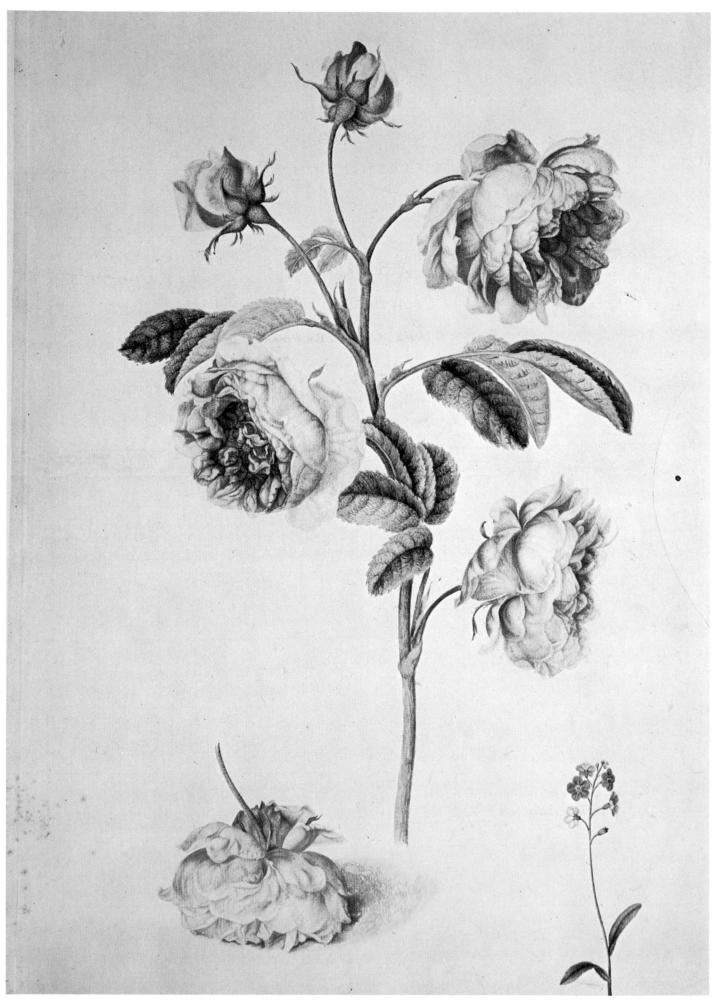

6

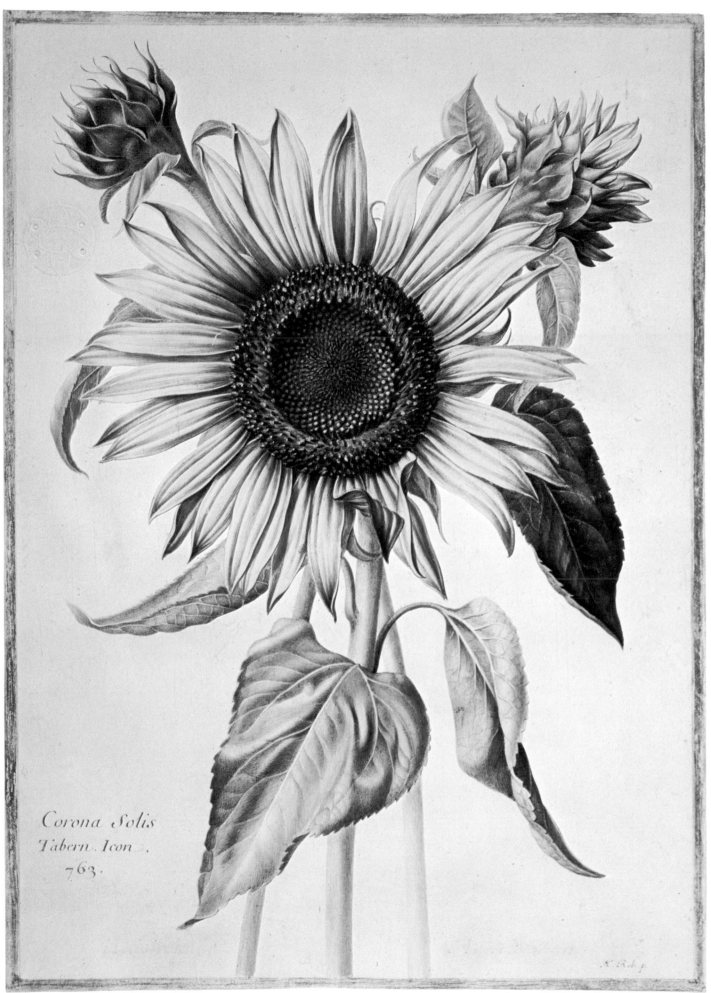

Corona Solis
Tabern. Icon.
763.

7

Helleborus niger,
Orientalis, amplissimo
folio, caule proealto,
flore viridi, Itineris
Tournefort.

8

Turnera frutescens, folio longiore et mucronato Miller.

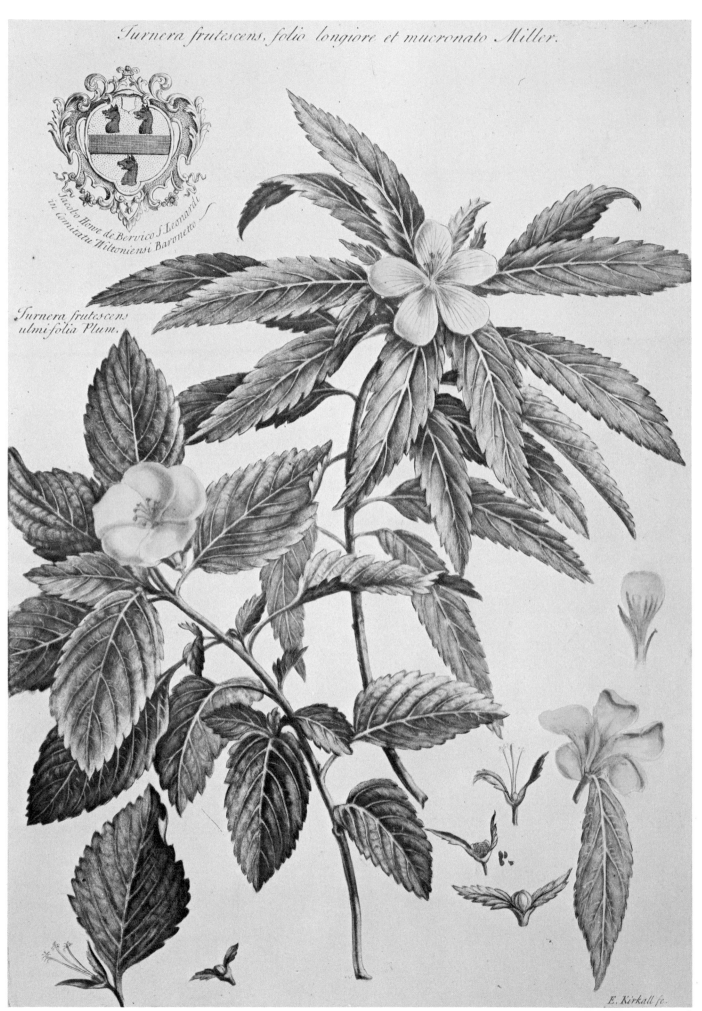

Jacobo Howe de Bervico S. Leonardi
in Comitatu Wiltoniensi Baronetto

Turnera frutescens
ulmi-folia Plum.

E. Kirkall sc.

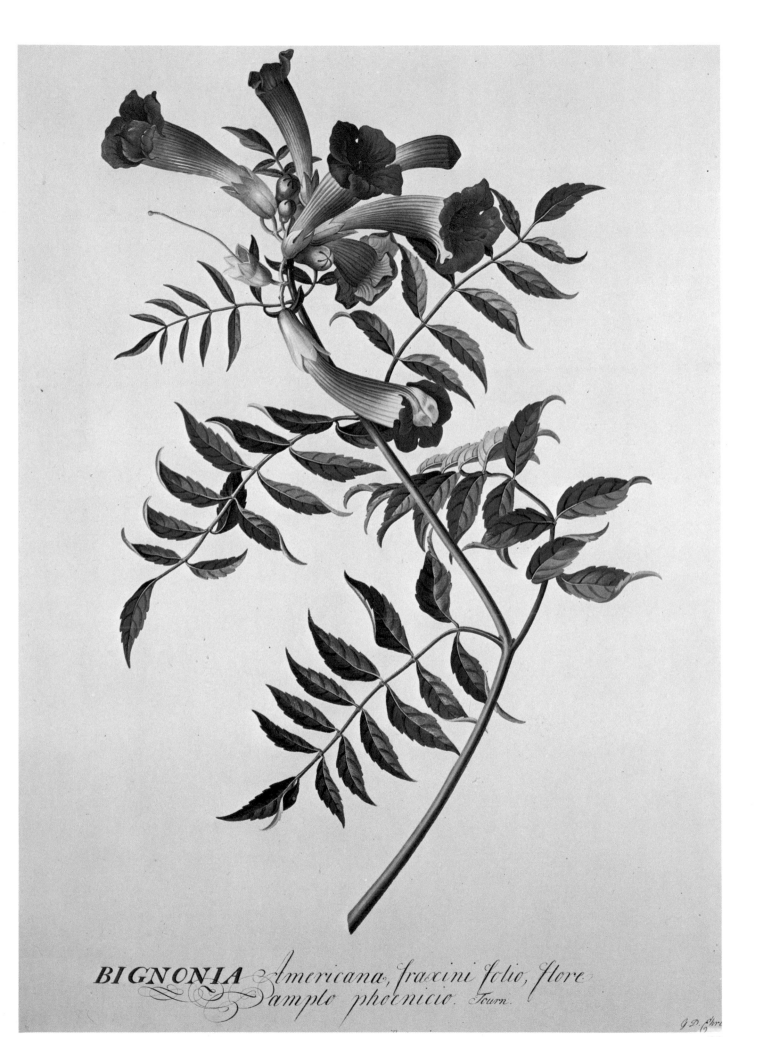

BIGNONIA Americana, fraxini folio, flore amplo phoenicio. Tourn.

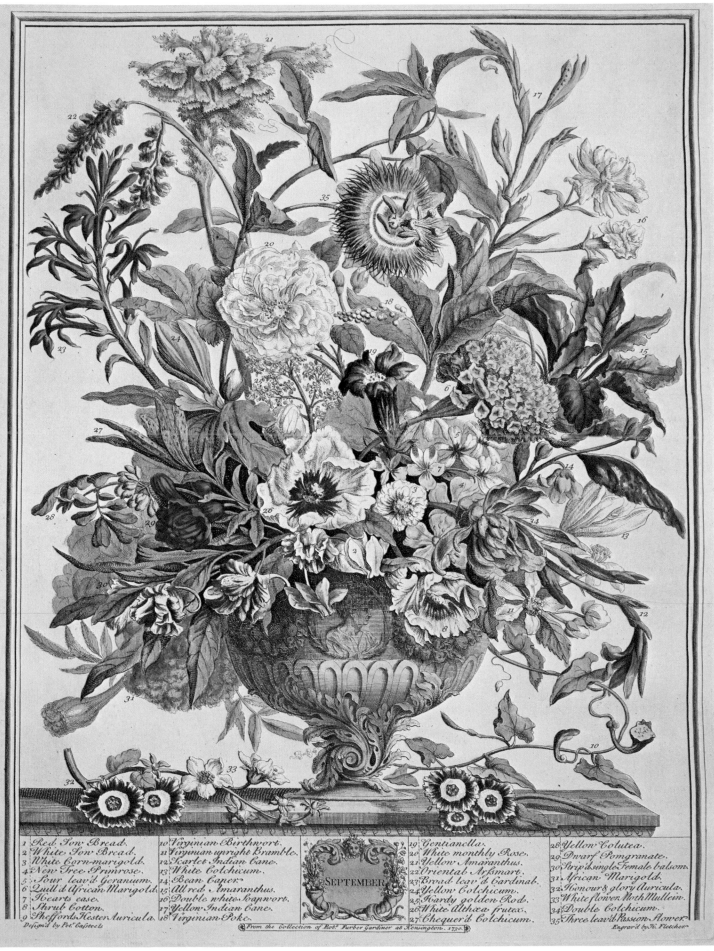

1 Red Sow Bread.
2 White Sow Bread.
3 White Corn-marigold.
4 New Tree Primrose.
5 Sour leav'd Geranium.
6 Quill'd African Marigold.
7 Hearts ease.
8 Shrub Cotton.
9 Sheffords Hesten Auricula.

10 Virginian Birthwort.
11 Virginian upright Bramble.
12 Scarlet Indian Cane.
13 White Colchicum.
14 Bean Caper.
15 All red Amaranthus.
16 Double white Soapwort.
17 Yellow Indian Cane.
18 Virginian Poke.

SEPTEMBER

19 Gentianella.
20 White monthly Rose.
21 Yellow Amaranthus.
22 Oriental Arsmart.
23 Broad leav'd Cardinal.
24 Yellow Colchicum.
25 Hardy golden Rod.
26 White Althæa frutex.
27 Chequer'd Colchicum.

28 Yellow Colutea.
29 Dwarf Pomgranate.
30 Strip'd single Female balsom.
31 African Marigold.
32 White flower'd Moth Mullein.
33 Double Colchicum.
34 Double Colchicum.
35 Three leav'd Passion flower.

Design'd by Pet.r Casteels

From the Collection of Rob.t Furber Gardiner at Kensington. 1730.

Engrav'd by H. Fletcher

11

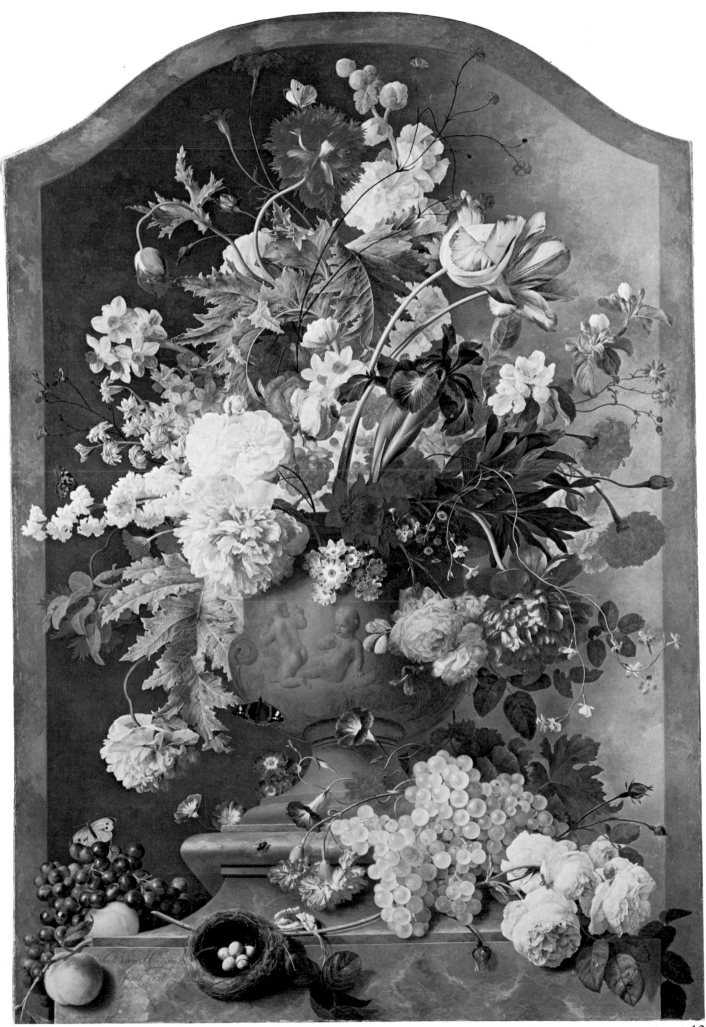

12

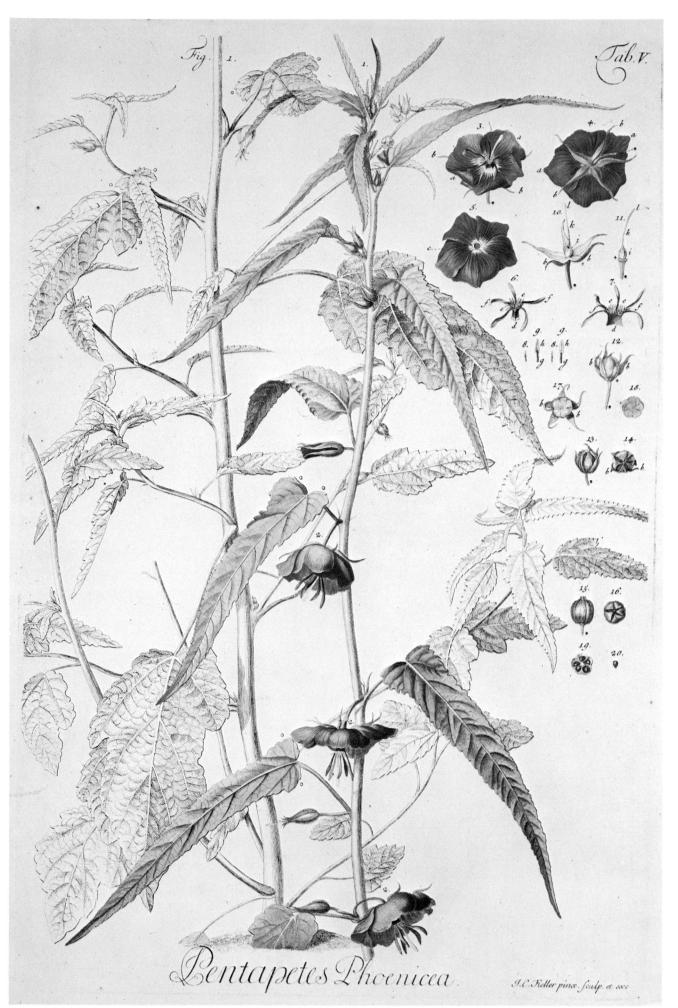

Fig. 1. Tab. V.

Pentapetes Phoenicea.

J.C. Keller pinx. sculp. et exc.

13

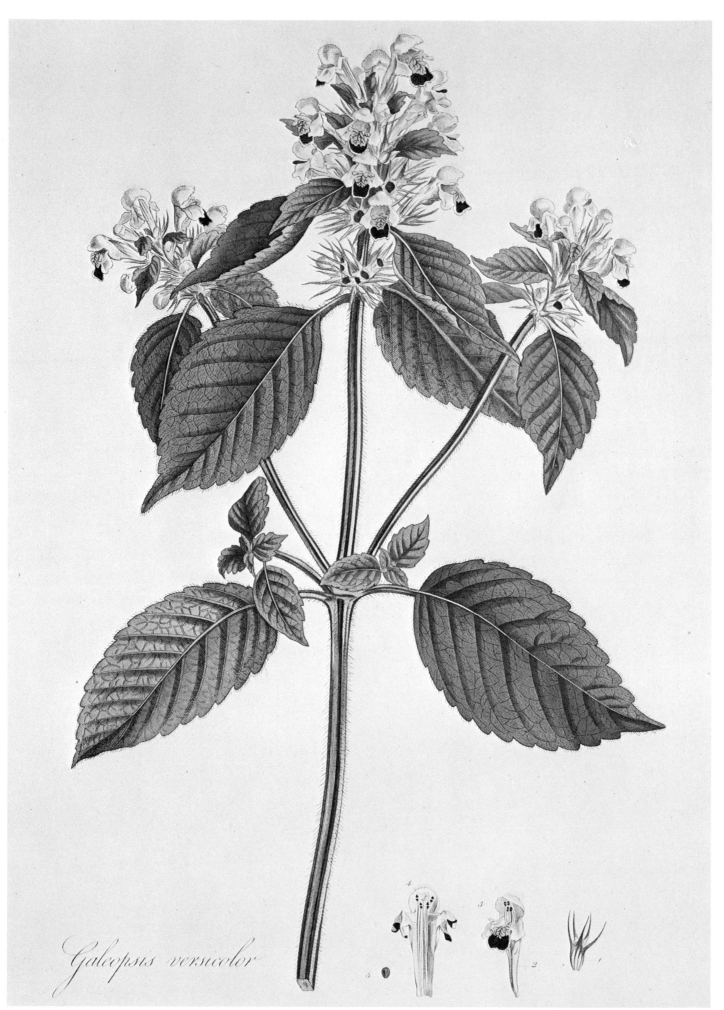

Galeopsis versicolor

14

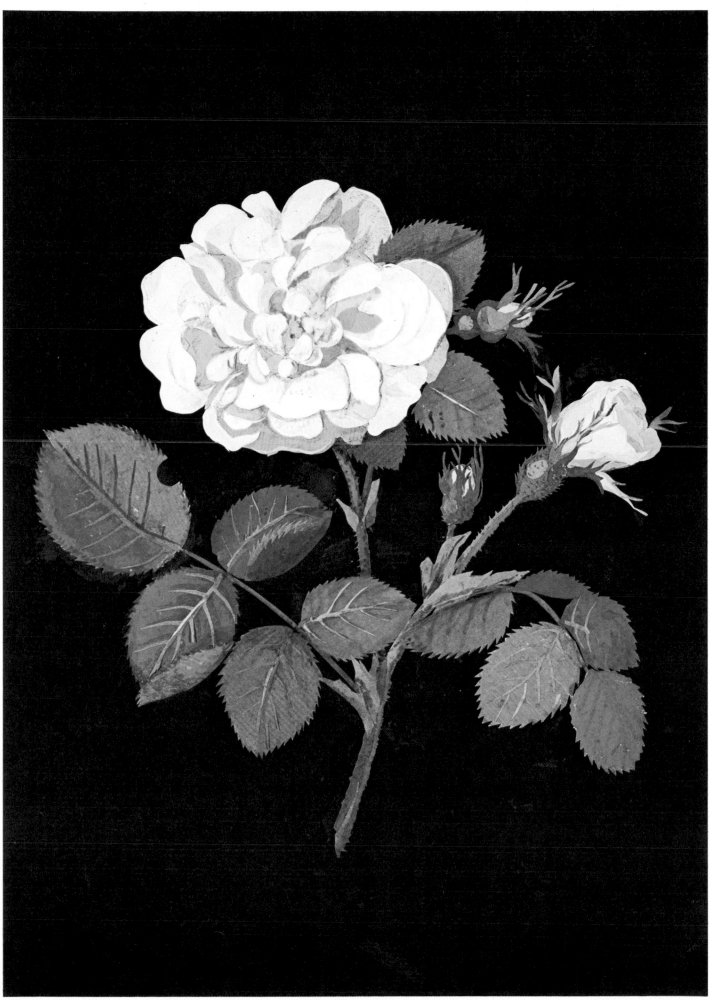

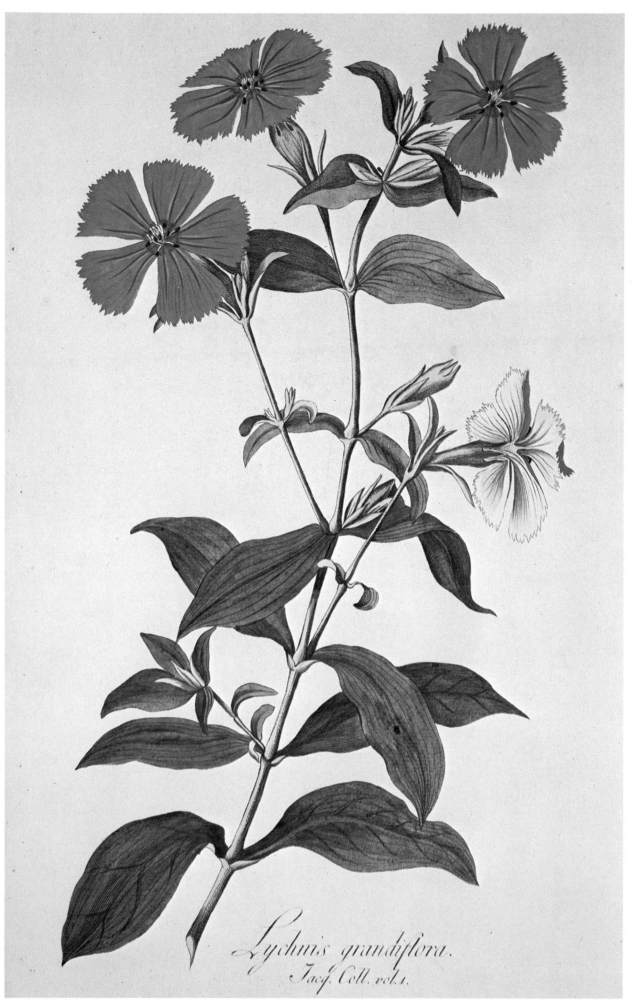

Lychnis grandiflora.
Jacq. Coll. vol. 1.

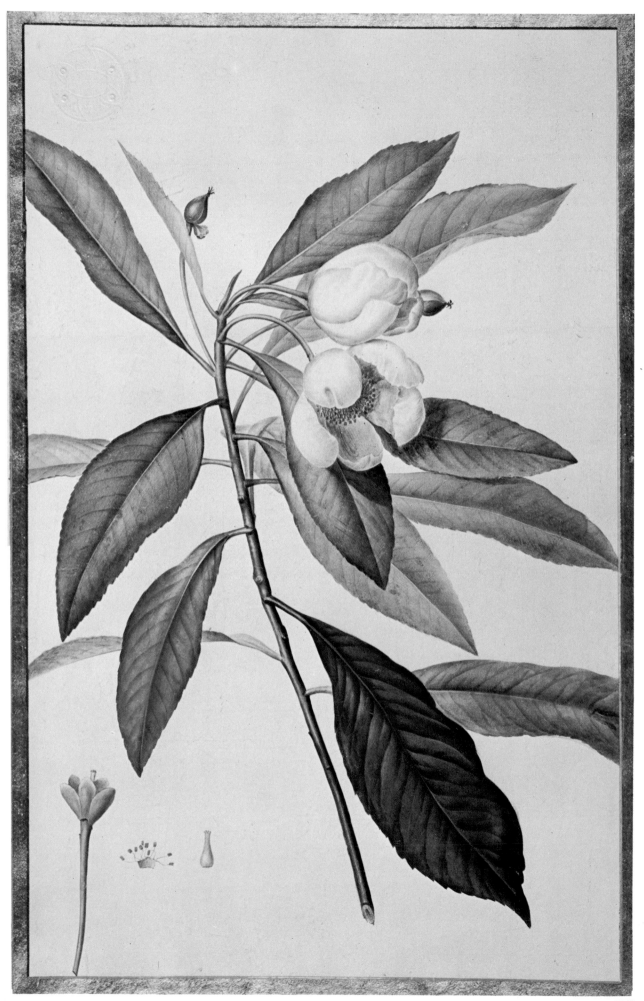

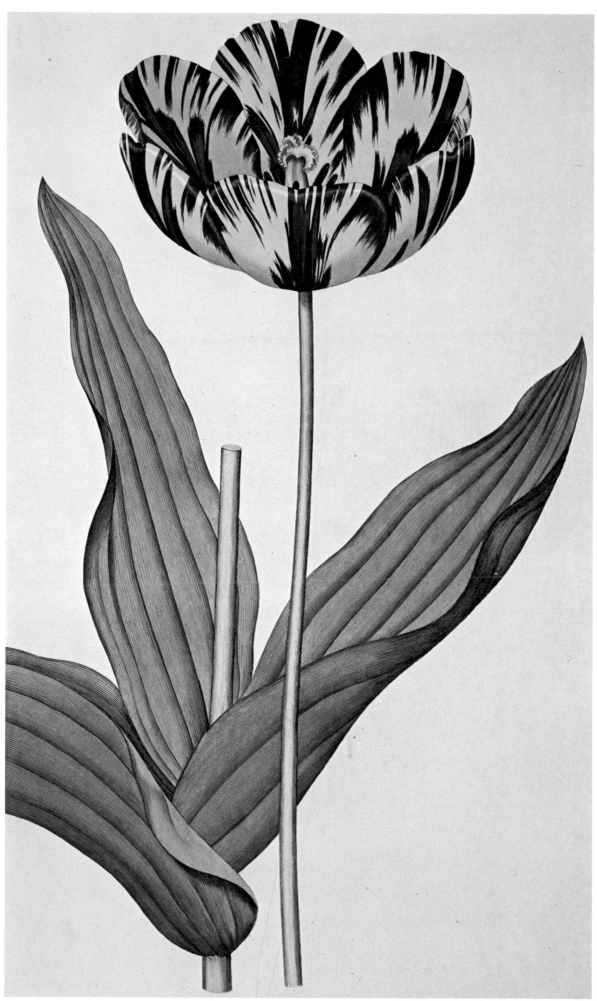

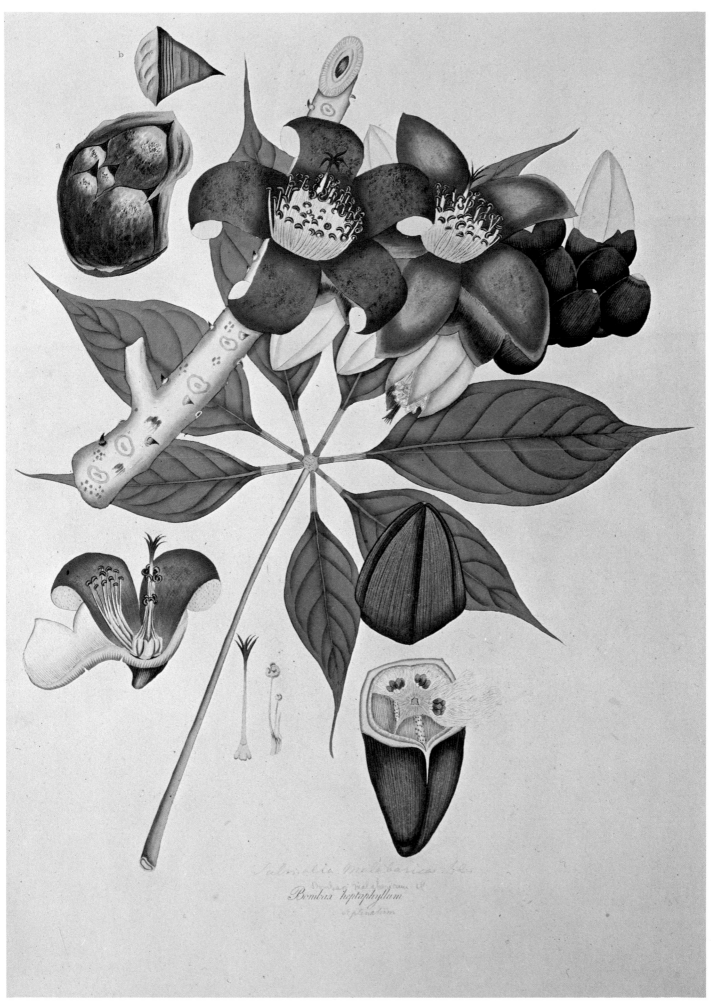

Salmalia malabarica

Bombax heptaphyllum
septenatum

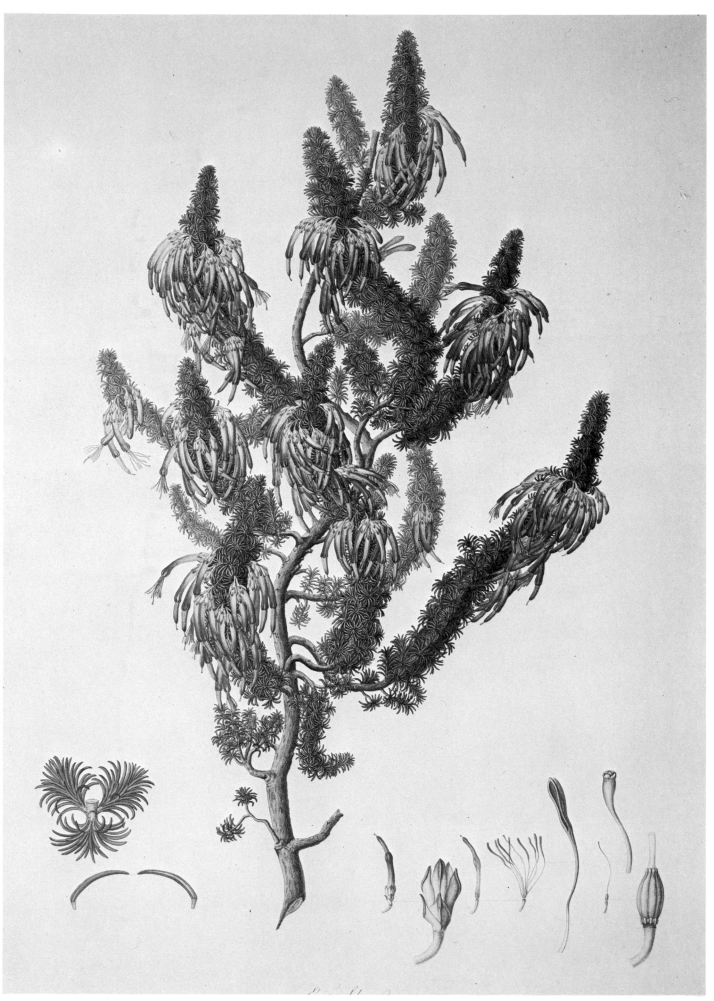

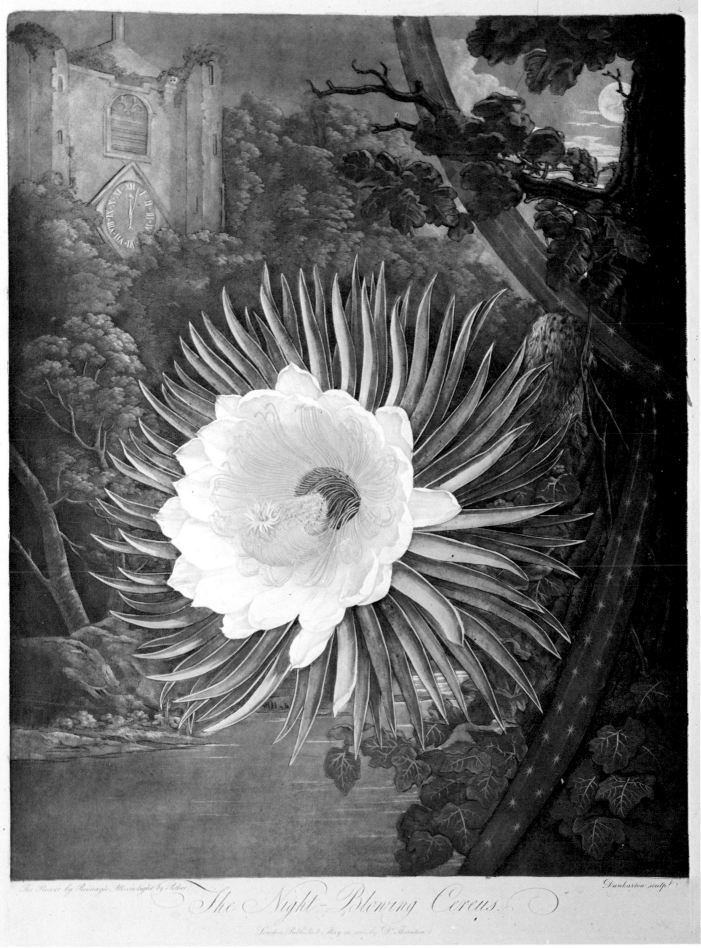

The Flower by Reinagle, Moon-light by Pether. Dunkarton sculpt.

The Night-Blowing Cereus.

London Published May 20 1800, by D.r Thornton.

21

Pl. 42.

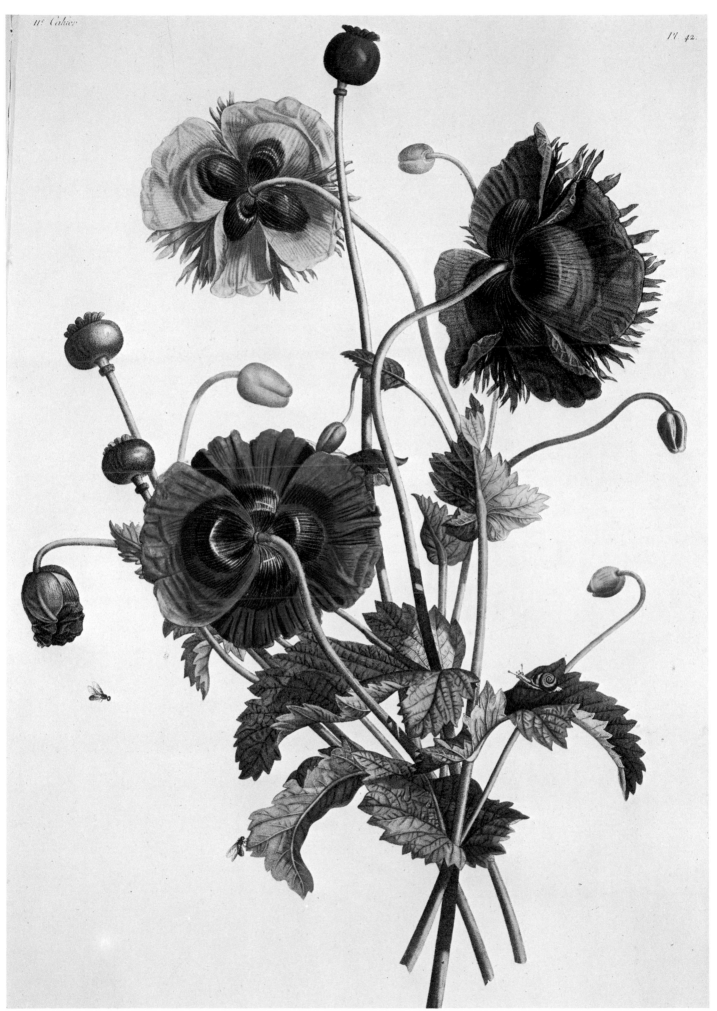

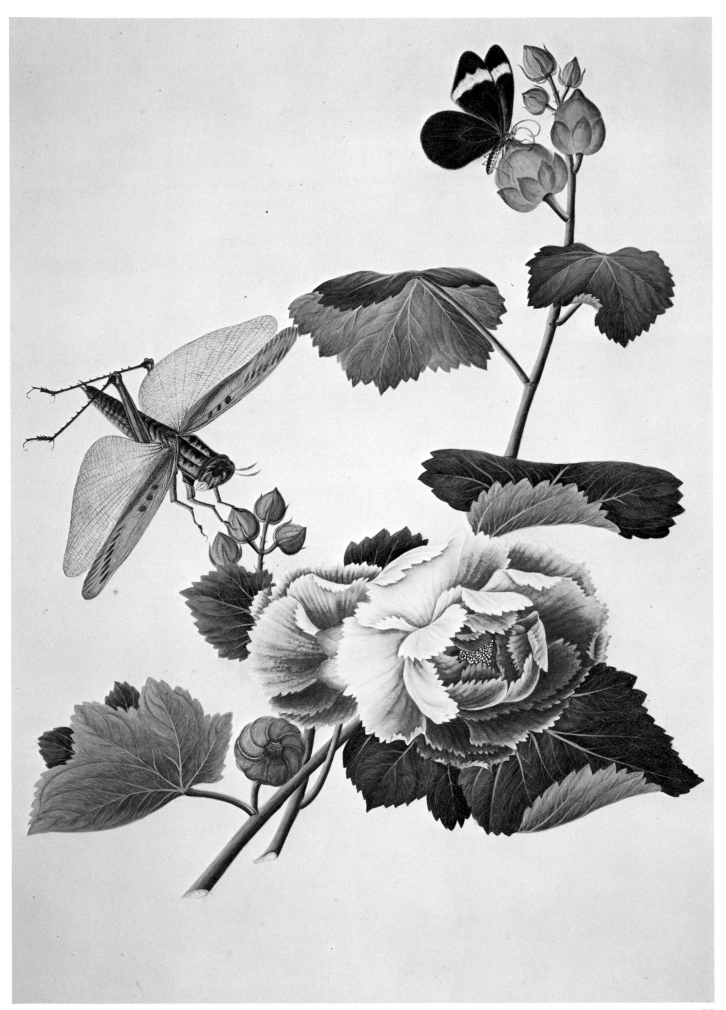

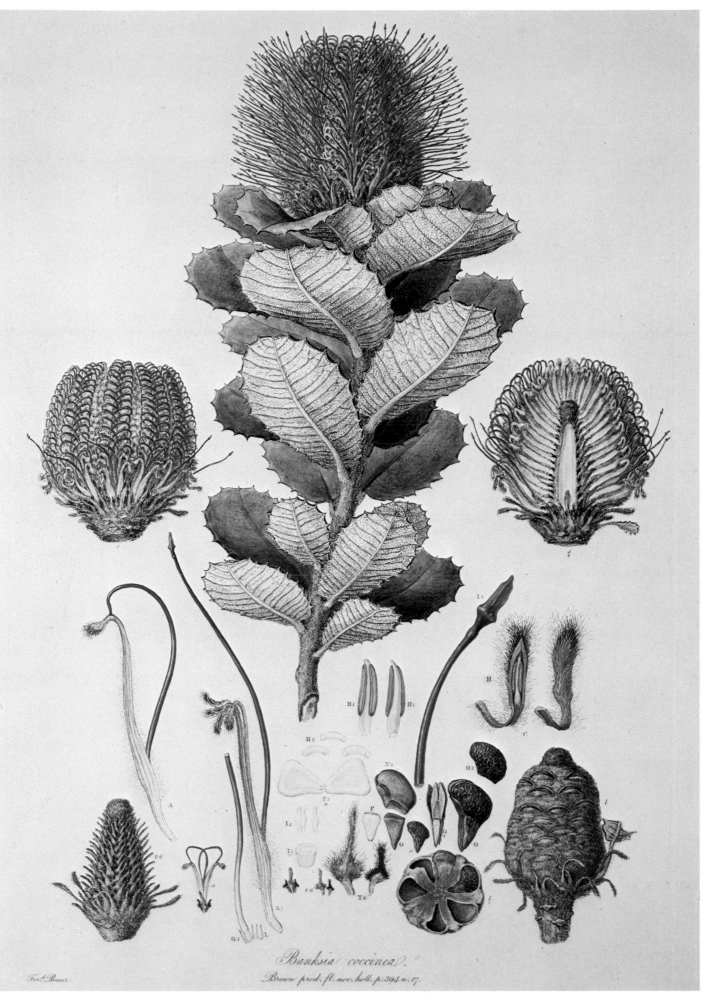

Banksia coccinea.

Brown prod. fl. nov. holl. p.394. n.17.

Ferd. Bauer.

24

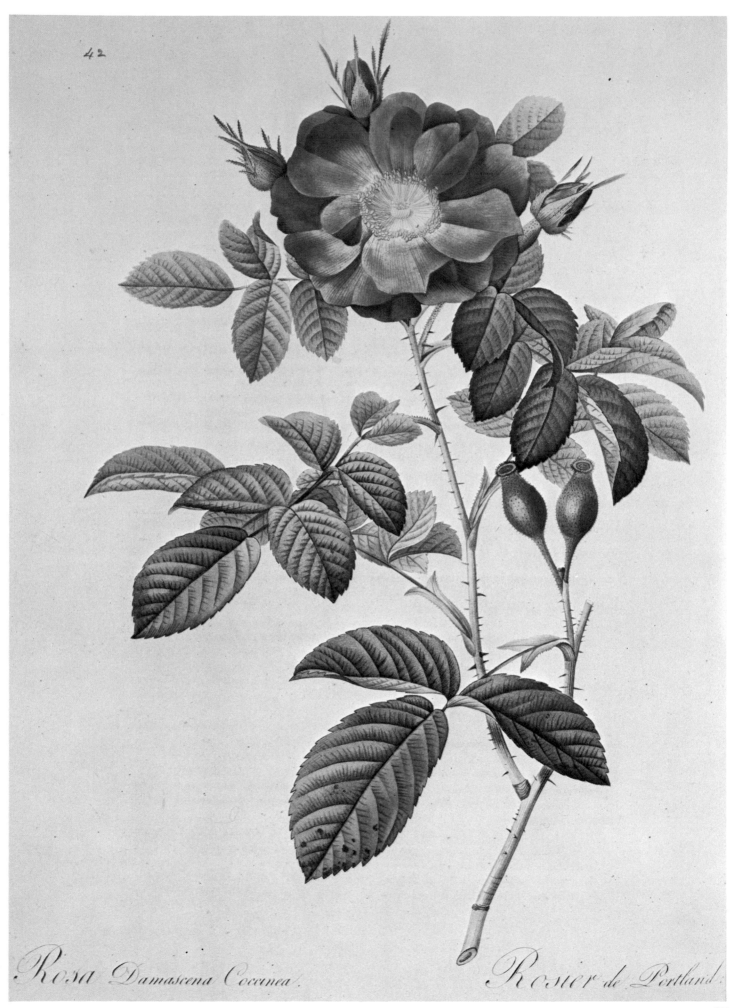

42 *Rosa Damascena Coccinea.*

Rosier de Portland.

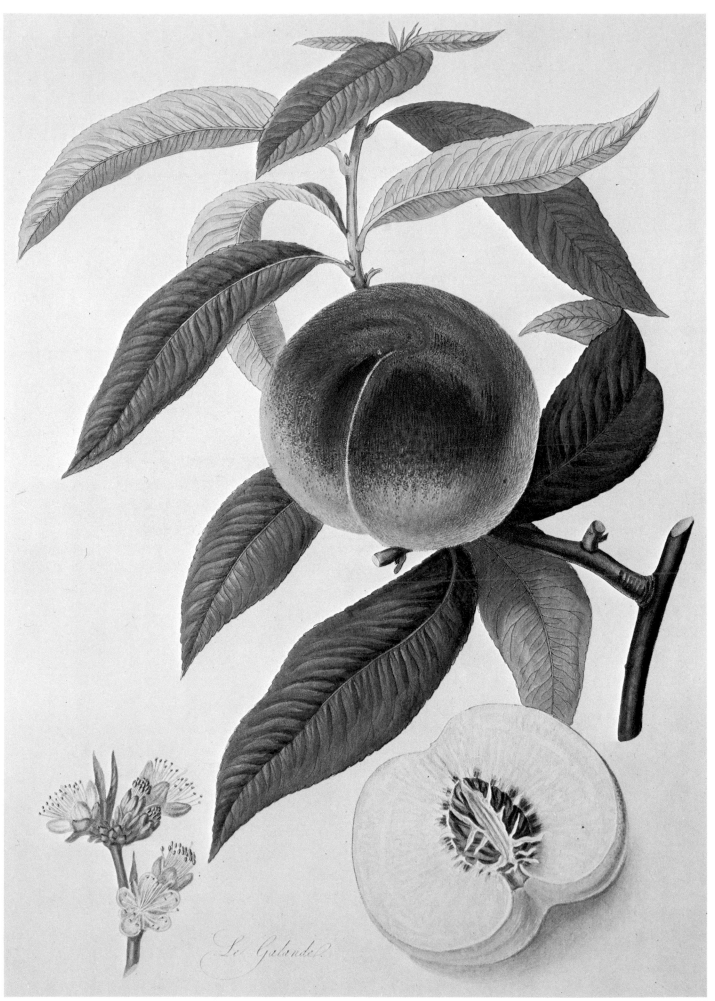

Le Galande

26

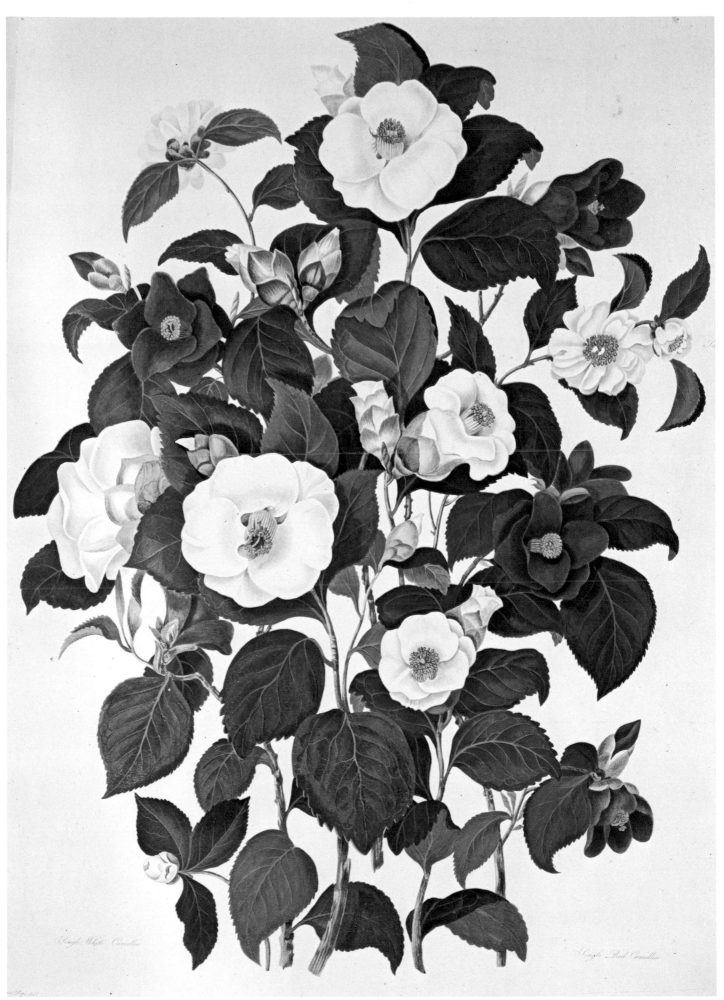

Single White Camellia

Single Red Camellia

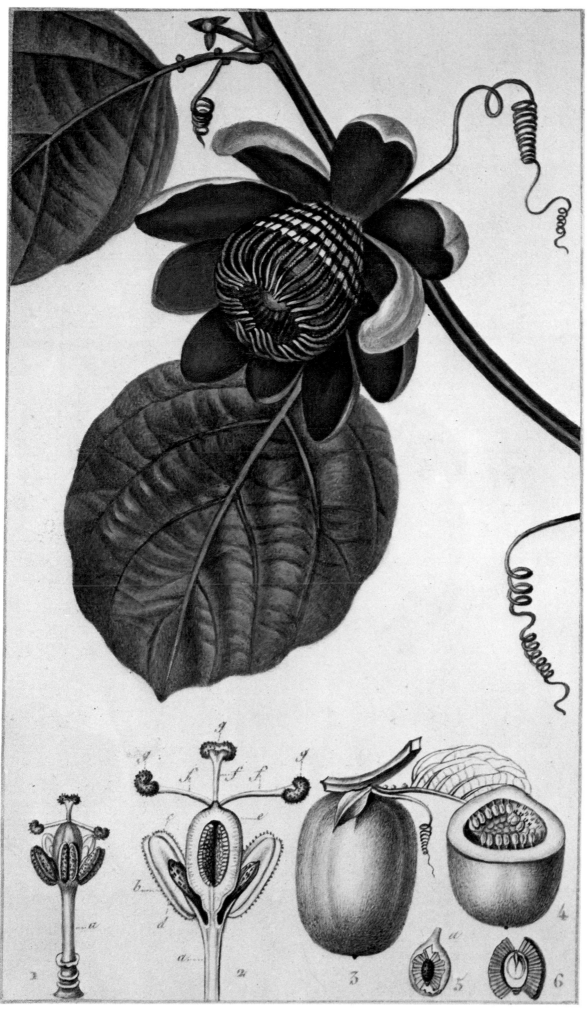

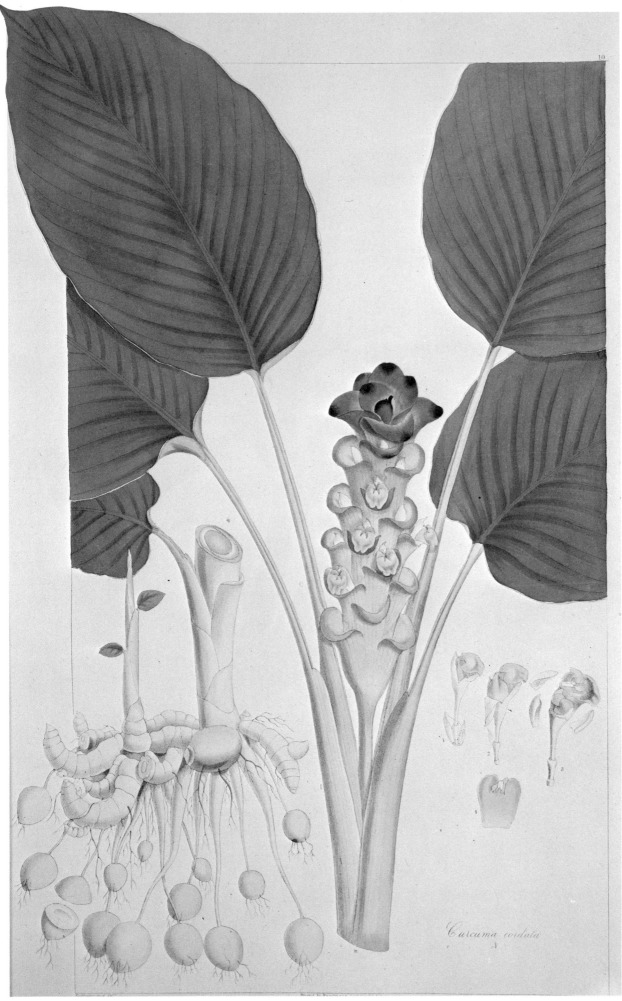

Curcuma cordata

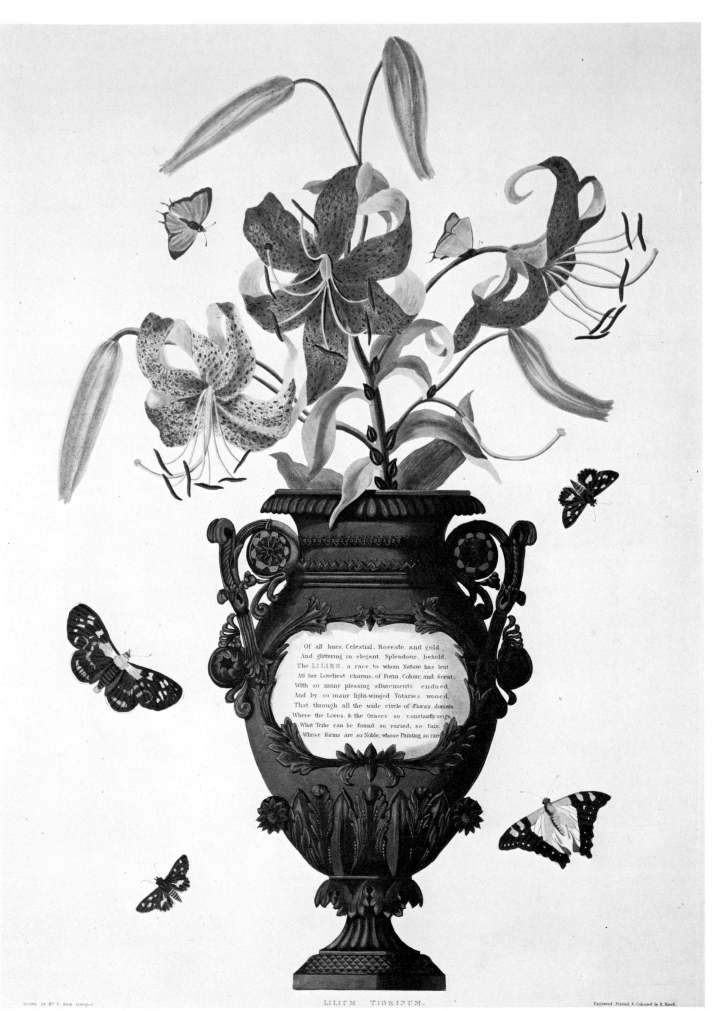

Of all hues, Celestial, Roseate, and gold
And glittering in elegant Splendour, behold
The LILIES, a race to whom Nature has lent
All her Loveliest charms, of Form, Colour, and Scent,
With so many pleasing allurements endued
And by so many light-winged Votaries woo'd,
That, through all the wide circle of Flora's domain
Where the Loves, & the Graces so constantly reign,
What Tribe can be found so varied, so fair,
Whose forms are so Noble, whose Painting so rare!

Drawn by Mrs E. Bury, Liverpool LILIUM TIGRINUM. Engraved, Printed, & Coloured by R. Havell.

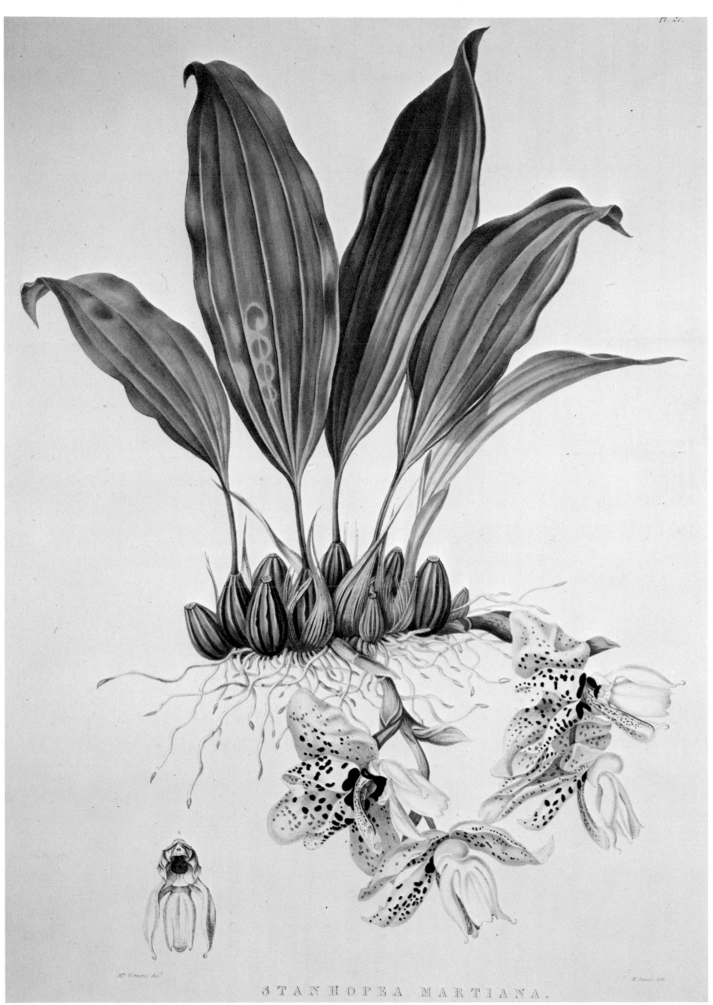

Pl. 31.

STANHOPEA MARTIANA.

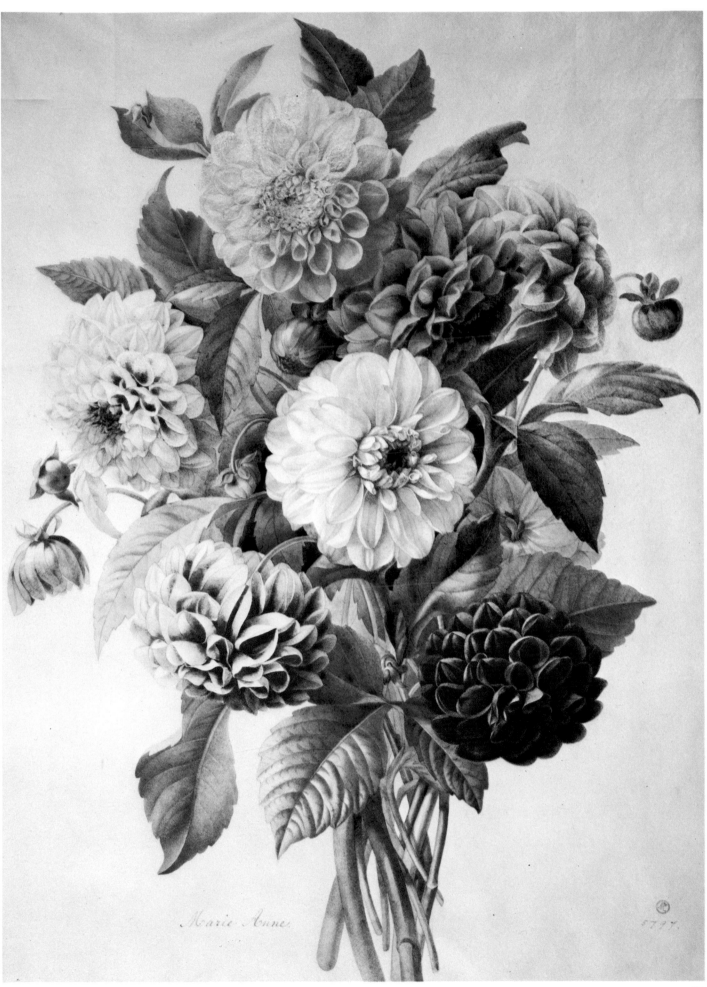

Marie Anne

5797.

32

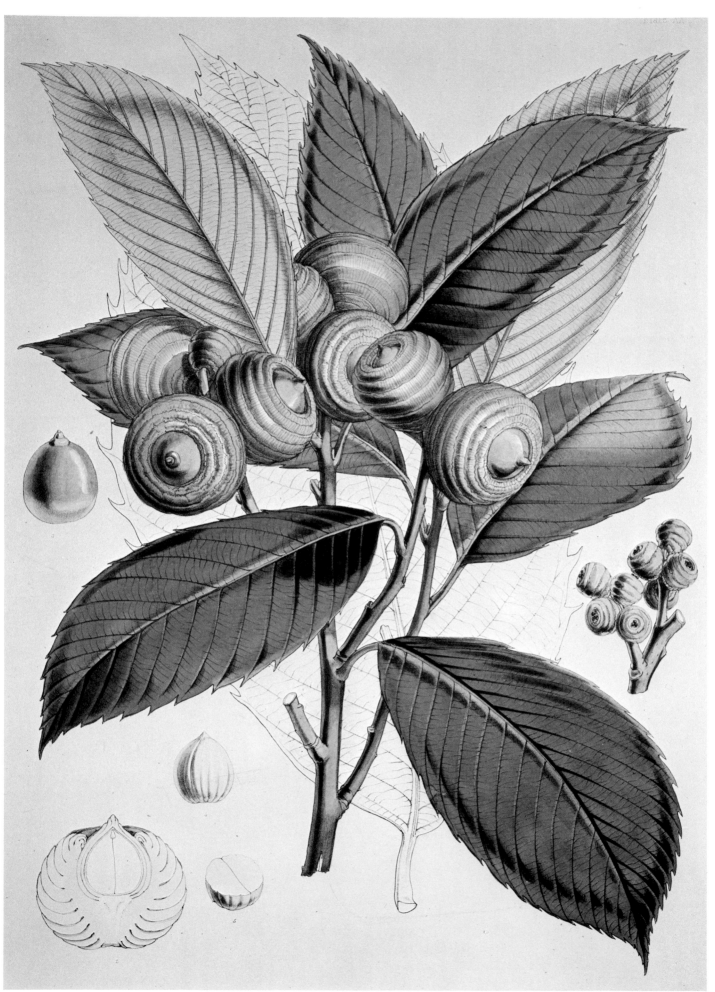

33

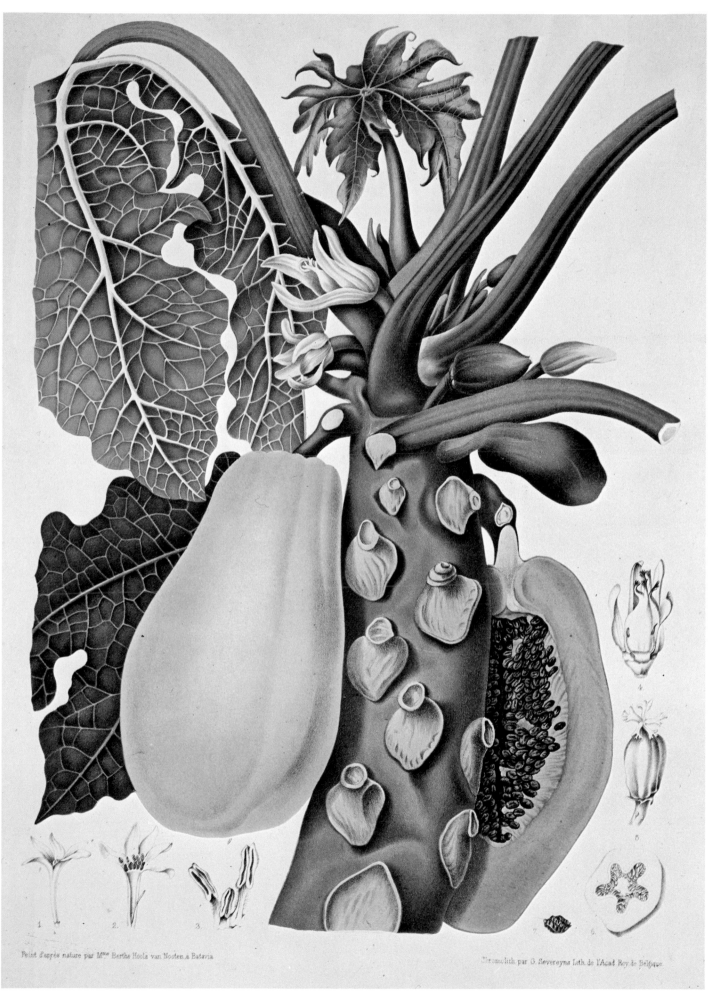

Peint d'après nature par Mme Berthe Hoola van Nooten a Batavia. Chromolith. par G. Severeyns Lith. de l'Acad Roy de Belgique.

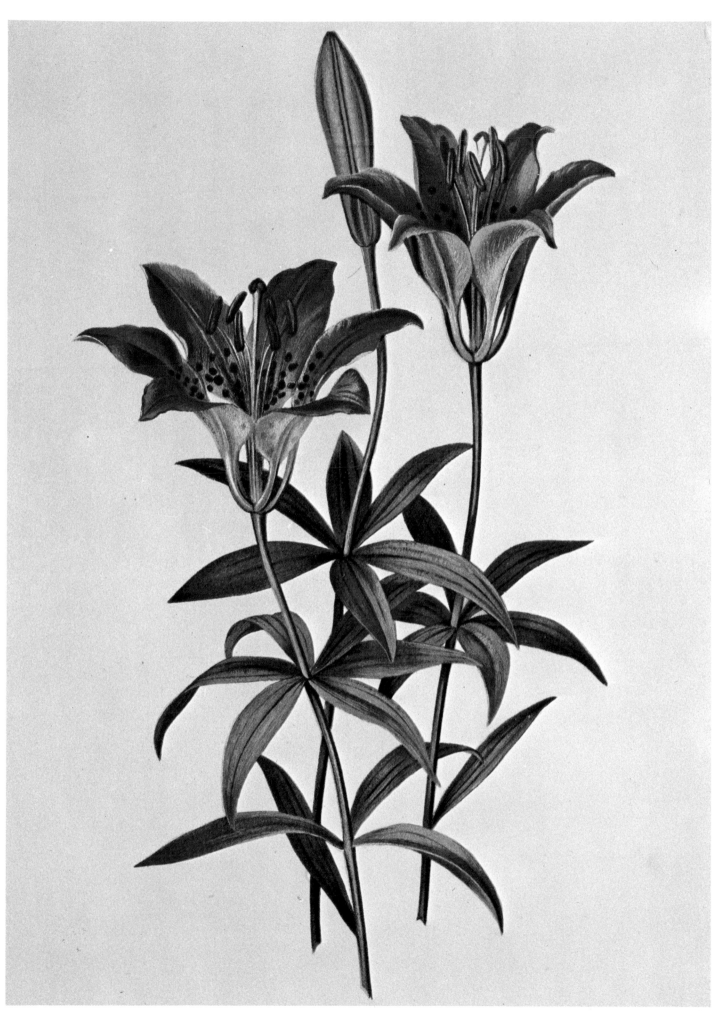

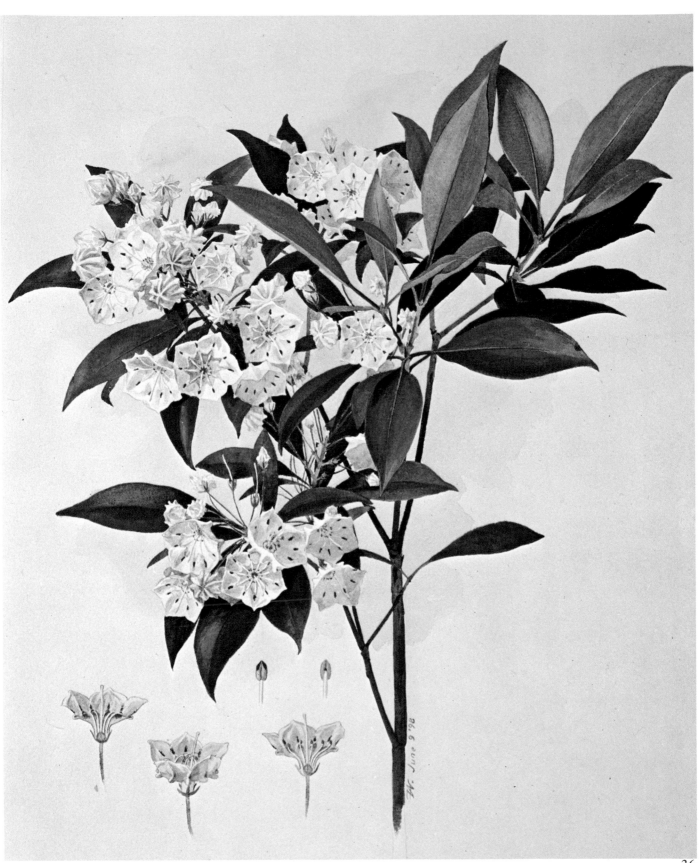

36

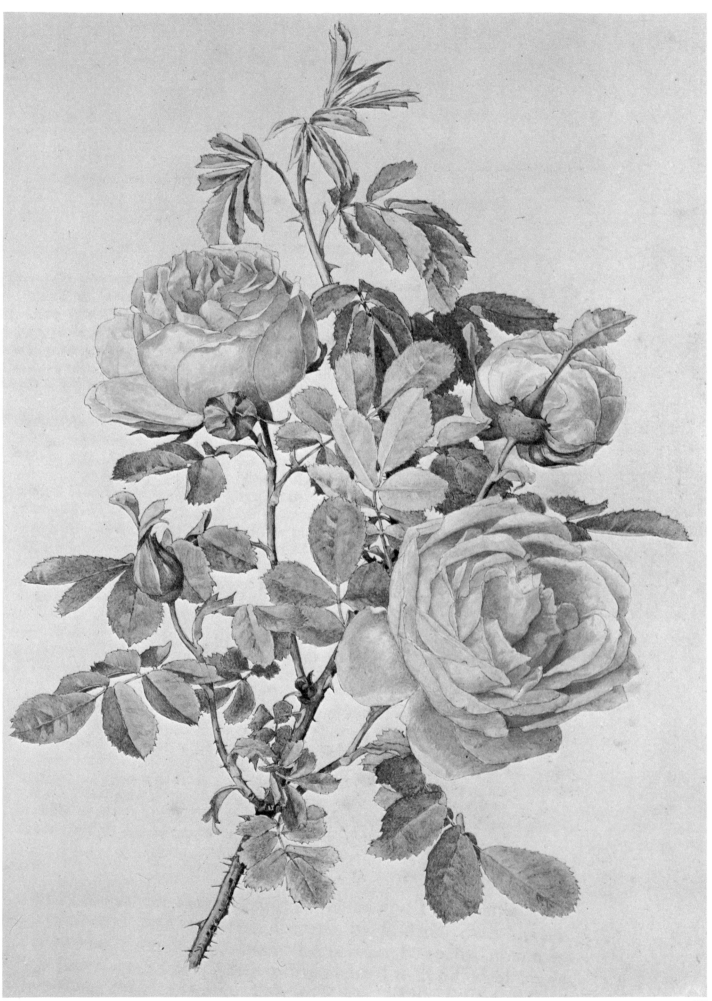

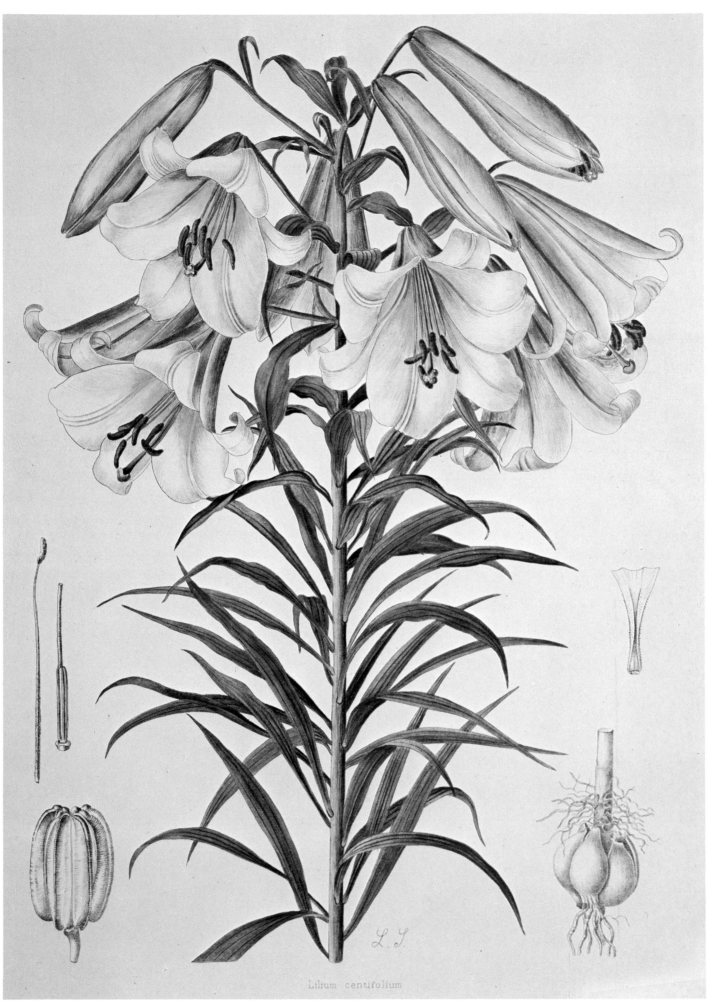

Lilium centifolium

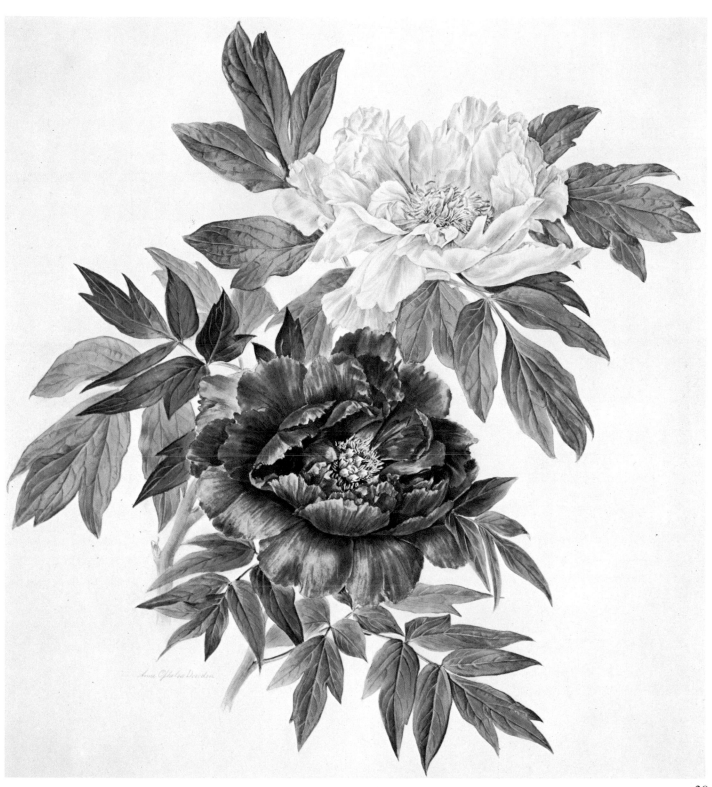

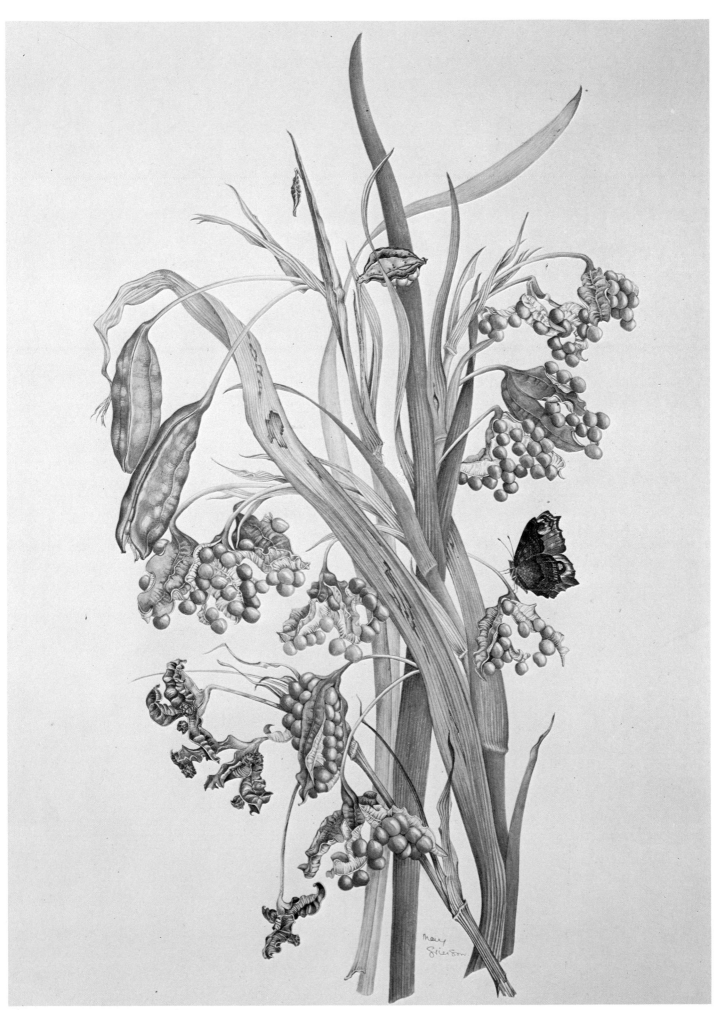